ILLUSTRATION
101

SECOND EDITION

Streetwise Tactics for Surviving as a
Freelance Illustrator

Max Scratchmann

The Technical Stuff Page

This book was originally published as an e-book by
Max Scratchmann in 1999
This revised edition published in 2006 and updated in 2007 by
Poison Pixie Ltd

www.poisonpixie.com/nonfiction.htm

2 Names and addresses of printers, site-hosts etc, contained within the text of this book are provided for information only and *no* endorsement is given by either the author or the publisher. Any reader entering into a transaction with any of these bodies should satisfy themselves of all terms & conditions before making any decision to purchase.

British Library Cataloguing in Publication Data

Scratchmann, Max

freelance illustrator
1. Commercial art
I . Title
741.6'068

ISBN 0-9537307-1-9
ISBN 978-0-9537307-1-1

 2 3 4 5 6 7 8 9

In Loving Memory of
Rose Garvie
1917 - 1999
Chic Garvie
1916 - 2005
and
Bunty Campbell
1916 - 2001

3

4

"There is only one difference between a madman and me. I am not mad."

Salvador Dali

Introduction -
Why Use Illustration?

"An illustrator is someone who couldn't make up his mind between fine art and graphic design"

anonymous

We live in an age where images are cheap and ten-a-penny. An art director can slip a stock-art CD into her Mac and illustrate a piece of work faster than it takes her to reach for the phone and ring you up. So why should a client actually use your services when she has hundreds of quicker and cheaper options at her finger tips?

No two illustrators will give you the same answer to this question, but, for my money, a client will only use a real live illustrator when she wants **Vision**. A 'real' illustrator, and I mean an ***Illustrator*** with a capital "I", provides qualities that a pre-conceived image cannot, and clients know this. A real illustrator is always inspired. She thinks in pictures. She has images dancing before her eyes. You can easily survive without an art school diploma, but you'll get nowhere in illustration without ***Vision***. Art Directors can get off-the-peg images anywhere, so when a client actually goes through the effort of commissioning you she needs something more than just a quick picture - she needs that vision.

Illustration is a very funny business. It is, on the one hand, nothing to do with art and, on the other, *everything* to do with it. Clients don't use us because they want art *per se*. They use us because they want our art to *sell*

6

"If it sells it's art"

Frank Lloyd

something with. What will sell better? A pack of Jaffa cakes in a blank wrapper or a pack with a beautifully executed illustration of ripe juicy oranges, dark, dark chocolate and spongy-biscuits that are so tender and fluffy that you just can't wait to sink your teeth into them?

I love photography, but there is no photograph in the world that can compete with an illustration to do a job like this, and *that's* why clients hire us. They need our art. They may think of us as mere 'sales-aids', which might be true, but our very sales ability lies in the heart of our Art, our Vision. *That* is what clients need and what we as illustrators, no, damn it, as *artists,* have to offer them.

If you are serious about becoming an illustrator then you have to believe in Art as a method of Communication. This doesn't mean that you have to forsake your principals and constantly churn out bland stuff to appeal to the lowest common denominator in order to please clients - true art will *always* win the day and is worth fighting for - but you must be able to produce and *enjoy* art that speaks to many people. If you really want to stick carcasses in formaldehyde you might be happier in a gallery rather than illustration - but remember that we are *not* the poor cousins of fine artists. Brad Holland, Janet Wooley and many others have proved that illustrators can be just as 'artistic' as anyone on the walls of the trendiest gallery and still prosper.

Illustration, like any artform, is about finding your niche. If you love glowing pictures of food and happy families you will do well in advertising. If you like more complex imagery, editorial and publishing work will embrace you. If you live for pulpy, punchy images there are thousands of book jackets just crying out for you. The possibilities are endless. However, whatever field or combination of fields you decide on, at the end of the day it is your vision and artistic integrity that really matters.

Material Things You'll Need When You Set-Up As An Illustrator

Phone - essential

Answerphone and/or Mobile - essential, especially if you do short-deadline work

Portfolio - essential

Business Cards - essential

Fax - not nearly as essential as it used to be

E-mail - taking over from faxes and getting to be essential

Website - highly desirable but not quite essential

Doom merchants will tell you that there is no future in illustration, that the markets have contracted and all the clients are Philistines. This is simply not true. Yes, there is a marked decline in the amount of illustration being used in traditional sources like women's magazines, but whole new vistas like the web, DVD menus, graphic novels and mobile phone images, many of which were unheard of only twenty years ago, have opened up and embraced us.

If you have made the effort to buy and read this book I know that you have the **Vision** to create great images, the **Enthusiasm** to go out and knock on art-directors doors and the **Determination** to succeed that singles you out from the common herd who flock into illustration each year and flock out just as fast. Read the following chapters carefully and take my experience on board. I am not a guru, I don't know the meaning of life, but if you think that any of the things that have worked for me over the last twenty years will work for you then please incorporate them into your own career plan.

You can contact me with your stories and suggestions for future editions of this book at **marketing@poisonpixie.com**. (For obvious reasons I can't take phone calls, enter into disputes on your behalf or guarantee a reply.)

I wish you many years of happy illustrating!

"My formula for success is rise early, work late and strike oil."

Paul Getty

1

Setting Up as An Illustrator

"A very funny business, I kid you not"

Leo Baxendale

Your first step in the process of becoming a high-profile illustrator is the creation of a stunning **portfolio**. Broadly speaking, your portfolio is your artistic credentials. It shows prospective clients *at a glance* that you can actually do what you say you do, who you've done it for and how well you do it. In other words, it is a key that will unlock many doors for you!

Portfolios can be any size from small, compact A4 folders to mega A1 monstrosities. I don't personally recommend A1 folders - not only do they tend scream *"STUDENT!"* at your client, but they are usually bigger than the average art director's desk! My own preference is an A3 display portfolio, not too big and not too little. My own weighs about 10 lbs. nowadays but it *is* good for clearing a path through the rush-hour crowds on the tube when I'm in London.

Portfolios should always be Visual first and explanatory second. Art Directors are not interested in a list of your past clients, they want to look at your past work, which, in theory, should be a collection of previously published pieces which make it pretty obvious what you've done and who

Hot Tip! Live Local - Work Global (Tip 1)

When I lived in the Orkney Isles I met and became friends with veteran **2000AD** artist, Jim Baikie. Jim and myself were both approached by a young illustrator called Britt Harcus who wanted to know if she could continue to live in a far-flung place like Orkney and still have a career in illustration. We both gave her the same answer.

12

As most clients prefer not to have you around making their offices look untidy, and as, nowadays, most work is submitted digitally either via email or FTP, you can live happily in seclusion and get work everywhere. Right?

Wrong! Most illustration commissions come out of metropolitan centres like London or New York, and if you don't choose to live in these places that's fine, but you *must* be prepared to visit them fairly regularly to meet clients and periodically renew acquaintance with existing ones.

Clients are dear old birds but they are also extremely fickle. They go for what's under their nose, so make sure that you remain flavour of the month - there are plenty of other illustrators waiting to step into your shoes!

you've done it for. However, you can also include things like press clippings about you in your portfolio, even they happen to be negative! For example, a member of the God-squad once took great offence at an illustration I did for *The Big Issue* in Manchester and wrote a hysterical letter about me to the magazine. The *Issue* decided to print it and I displayed both the letter and the offending illustration in my portfolio. It made a great talking point!

What exactly goes into *your* portfolio will, of course, very much depend on where you are starting your career from. The choice of images is entirely up to you but remember that clients are looking for two things in an illustrator's portfolio - **talent** and *experience*. If you have been illustrating for quite a while this will pose no problems as you will have a wealth of work available to you to illustrate both your genius *and* your work-history. However, if you're a graduate or just starting a career from scratch it's going to be a *little* more difficult. Some art directors are cool with college work but if you *really* want to wow them, try to show them that you've already been out and created in the Real World. To do this you might need to do a little *Pro Bono* work or **Portfolio Investment**.

"Portfolio Investment" in simple English really just means working without getting paid for the greater good of your career, and is something that *all* illustrators should do throughout their working lives. OK, OK, we all want to work for loadsamoney but sometimes taking little or no money for a job now will pay huge dividends in the future - particularly if the job is something you really want to do and doing it for free this time will bring you in more of the same in the future, only this time with cash behind it.

So, decide where you'd like your career to take you. Do you want to concentrate on food adverts or film posters? Bearing what you want to do

Hot Tip! Live Local - Work Global (Tip 2)

Whereas the main source of your work as an illustrator will come from London there are plenty of other sources throughout the UK, so don't discount the possibility of nurturing *local* clients. Most towns run to some form of magazine and / or newspaper, an independent record label and a small publisher or poetry house.

If your town has a university they will almost certainly have a press of some form, and even if they only produce a prospectus there's the chance that they'll need an illustration or two. I did loads of great work in Manchester with clients like the *Big Issue in the North*, Manchester University Press, *City Life* Magazine (Manchester's *Time Out*) and loads of small press publishers and organisations.

Check out your area Yellow Pages and pay a visit to your local Enterprise Centre and see if they have a skills database where they can store your details and put you in touch with businesses in the area with something to sell who might need your services.

in mind start at "community level" and get some unpaid work in your chosen field. Look around you, your local church, charity or community drama group probably has a magazine that needs covers or events that need posters. Offer your services for free or expenses only and give the job the tender loving care you would give to a commission from *Saatchi & Saatchi*. Whatever you take on give it the proverbial one hundred and ten percent. Create awe-inspiring images for good causes and collect evidence of the great job you make of it in your portfolio to show future clients.

A word of caution, though. We've all heard the old saying "be careful what you wish for it might come true" and portfolio building is laced with the same magical menace. Clients, as I've said, are strange old birds. Many a time a 'prospect' has been leafing through my portfolio disinterestedly when something catches their attention, their eyes light up and their speech becomes husky as they intone "Can you do *that* for me?" So, children, the golden rule of portfolio building is, ***never, ever, include anything in your portfolio that you wouldn't want to do again.*** Remember, a portfolio is *not* a CV. You're not giving your client a step by step résumé of your career to date, you're offering to do a particular job of work for your client and your portfolio is your guarantee that you can, in fact, do that job, and do it extremely well!

I'm afraid, however, life is not always fair and sometimes you wont be able to find anybody who'll even take you on for free. (Fools!) You'll be going to some two-bit organisation offering to do a *gratis* job with the purpose of gaining experience & building up your portfolio and they'll be asking to see a portfolio from you before they let you have any work to build up your portfolio with. It's crazy, but worry not. We've all been here! Build the foundation of your portfolio with "mock-ups", or, to go back to layman's terms, create work in your own time for fictitious clients or, even better,

Hot Tip!

Rowena Kidd of **Barrow Model Makers** in Manchester told me about how she actually whittled down her portfolio as she became more successful.

When she left a secure job as a model maker at Cosgrove Hall Animation to set up her own studio, Rowena's original portfolio included examples of *all* the work that she could do.

As more assignments came in and her reputation grew, however, she started to remove the type of stuff she really didn't want to do any more until, eventually, she ended up with a very select portfolio of only the type of material that she really wanted to take on.

assign yourself to create fictitious work for existing commissioning bodies.

Convincing mock-ups are easy enough to produce. Just do the work and lay it out as if it were printed in a book or magazine. If you set an illustration into a page of type and then scan or colour-photocopy it nobody will be any the wiser! My own portfolio started out with one commissioned piece and about fifteen mock-ups and I still have a couple of those mockups there over twenty years later because I've never tired of them! You can, of course, be up front with your mock-ups and acknowledge them as such if you want to, but should the client think that you did these as 'real' commissions there's no point in disillusioning the old darlings if it's going to land you the assignment you want, now is there?

Don't ever be fraudulent, folks, but it doesn't hurt to 'bend' the truth a little in your early days. Never, ever, get yourself into a job if other people's jobs, health or lives can be affected by it - like drawing the instruction illustrations for a life jacket, for example, if you haven't got a clue how it works - but if you *know* you can do it and have proved to yourself you can then by all means go for it.

A portfolio, like a dog, is for life, not just for Christmas! Don't skimp on it - it's your passport to the future, and I'd rather have no portfolio at all than a shoddy or sloppily put together one. Only an idiot would skimp on giving the product of his talent and labour the best display possible and this is what you must do with your portfolio.

If you have illustration in your blood it means that you *have* the skills and talents that clients want and need. Use your portfolio to showcase your skills to their absolute best advantage. Remember, clients see *lots* of illustrators it's up to you to show them that you are better than the rest of

GREAT PORTFOLIOS GENERATE GREAT WORK

the herd and your portfolio can do this for you.

Photocopy the facing page out and pin it up above your desk

19

20

"It's morally wrong to allow a sucker to keep his money."

W C Fields

2

Telephoning the Client

"The work will teach you how to do it"

Estonian Proverb

Getting Past the Secretary or How I Learned to Stop Worrying and Love Cold Calling!

A young illustrator came to one of my seminars and, during one of the breaks, hesitatingly approached me with a small portfolio which he asked if I could look over. Folks, this guy's work was **Amazing!** I was green with envy! I expected to see his wonderful imagery staring down at me from every poster hoarding in the land in a matter of months and yet, several years later, I've never seen a thing by him in print. Why? Because he refused to accept that if you want to work you've got to **cold call**.

So what's cold calling and why is it so vital? Simply put, Cold Calling is the name given to unsolicited telephone calls made by someone unknown to the recipient, usually to sell something, and, the first thing you'll discover about working in illustration is that, despite phrases like "pounding the pavements", you'll spend a lot of time with a phone connected to your left ear or, as they say in the adverts, "letting your fingers do the walking". We can, and should, send out mailers and samples, but if

Hot Tip! - Designers

I'm always saddened when I hear illustrators and designers bickering amongst themselves. Please empty your head of nonsense like "designers can't draw" and learn to love your designer.

Illustrators and designers need each other - we are yin to designers' yang. I have had some brilliant work ruined by bad or indifferent graphic design and some rather mediocre work made to look stunning by brilliant design skills.

22

So get out the Yellow Pages and find all the graphic designers (and web designers if you work digitally) in your area and give them a call. Make friends. It will not only bring you work but will help you find someone who knows how to lay your images out on the page - so if you ever land a job where you have the chance to pick your designer you'll have a tailor-made design buddy ready and waiting.

we are *really* serious about securing commissions there is nothing to beat face-to-face meetings with clients and the way to procure these is by cold-calling. Or, in layman's terms, the best and easiest way to get work is to ring up clients and say "Any work going?".

OK, you're going to have to be a *little* more sophisticated than this, but, if you always remember that the purpose of **all** your work-seeking calls is to simply ask the above question you'll have many happy hours of Cold Calling ahead of you and you'll avoid many of the pitfalls and heartaches associated with this art.

So, how do you cold-call then? Quite simply, think of all the people you want to work for, write down their names on a bit of paper, look up their numbers, ring them up and ask them for work. Easy-peasey Lemony-squeezy!

Alright, alright. I'm being facetious. It's a *little* more involved than that but, really, that's all there is to it once you've found your feet. Always keep this to the forefront of your mind and don't let Cold Calling become the scary monster that many people [self included!] have let it develop into. The success rate for an experienced cold-caller is about one "yes" for every seven "noes" but real experts can bring that down to about one in every five. It seems scary to start with but once you've done a couple of hundred it's tinker toys. Honestly!

So let's start by looking at Cold Calling from your client's point of view. It's Friday night. You've had one helluva week and just sat down to relax after the last hard day. You've put the kids to bed, walked the dog, poured the tea and put your feet up. You're just about to watch *Frasier* when the phone rings. You break off from what you're quite happy doing to answer

24

"Watch out when you're getting all you want: only hogs for the slaughter get all they want"

Joel Chandler Harris

and it's some dickhead that you don't know trying to sell you double glazing that you don't want. How would *you* feel? No need to answer, you'd just put the phone down, and that's exactly how *your* potential client *could* feel about *you* when you cold call. So let's start our work generating system on the right footing and learn how to do it properly.

Max's Golden Rules for Cold Calling

(1) **Do Your Homework**. Make sure that the person you're calling actually needs what you have to sell, or, in layman's terms, if you're selling illustration don't waste time (theirs and yours) ringing up clip-art merchants. They're not interested! As someone who's spent many, many hours Cold Calling, both for myself and for employers, I can assure you that a client who has no need for your service is a total waste of time and effort. Or, to put it another way, even the world's best illustrator will have his work cut out with a publication like Hansard which uses no images.

(2) **Get Your Timing Right** Please don't get paranoid about this. You can't *know* if it's a good time to call your client but if you set up a few ground rules you'll avoid the situation of being brushed off because the client can't be bothered talking to you. I once had a temp job selling ad space for a local newspaper where we were Cold Calling from nine to five, so I always prefixed my calls with "Is this a good time to talk?" (and if the client said no, followed up with "When can I call you back then?") but to get the best out of your freelance Cold Calling it might be a good idea to set up an *ad hoc* time table. I would suggest that you don't phone a client first thing in the morning when she hasn't had her coffee or organised her post, lunch time for obvious reasons (ie, she isn't there!) or last thing when she's trying to clear her desk and get out in time for the five-fifteen from Victoria.

"Have you ever noticed that wrong numbers are never engaged?"

Steven Wright

Obviously, everyone has their own preferences. I prefer to confine my Cold Calling to between 11 am and 12:30 pm, for example. I find that the art directors and editors who use me don't tend to be at their desks much before ten-thirty in the morning and by afternoon have either wandered off somewhere or have got involved in that day's project and don't want to be disturbed. The key to good timing, therefore, is to **know your sector of the industry**. When will *your* target art directors be at their desks and free to listen to your pitch?

(3) **Always Know Who You Are Phoning** Any book on sales will tell you all about speaking to the MAN, not a sexist preference but a snappy mnemonic for the person who has the MONEY, the AUTHORITY and the NEED. Throwing your pitch at anyone else is a waste of time. So, when you ring up a client the first thing you must establish is who you're speaking to. For example, if you want to get into adverting, there's no point in ringing up an ad agency and just asking if anyone there would like to look through your portfolio. For all you know you could be speaking to the janitor or, even worse, the office junior. To paraphrase an American book on the subject I once flicked through in Waterstone's [I can't remember the name of the book or who wrote it so I can't acknowledge this with a plug - sorry whoever you are!] don't pitch to anyone other than the Head Honcho. Many, many illustrators attend interviews with clients and never receive any work while lesser talents prosper. Why? Because the person you pitched doesn't have the authority to commission you and your business card is gathering dust in a barren filing cabinet.

Happy Cold Calling will result when you have the *name* of the Big Enchilada in your possession and can ask for her directly when you ring. Lots of the Art & Design industry is actually well documented and you can get all the contact names and numbers you need from directories like *The*

Digression

While we're on the subject, can I just take time out to talk about Assistant Honchos. These people can often be the illustrator's friend - but they can also be the illustrator's nightmare. I spoke earlier about illustrators being interviewed by people who don't have the power to commission. These peons vary from Assistant Honchos who are vetting you to, once in my own experience, a junior designer who was viewing portfolios to "gain experience". Sometimes it's difficult to know on the phone if you're talking to the right person as the conversation tends to go "Hi! I'd like to speak to the person who commissions illustration" "You can speak to me" "OK Would you like to look over my portfolio?" "Yes, come in tomorrow".

If you're still unsure when you've met the client, ask. If you're going down well, take the opportunity to ask about the commissioning process.

You: "So, will it be you that actually commissions me then?"
Client: "No, Frank does that" [Warning sign! Who's Frank? Is he the real Head Honcho]
You: "Oh, do I need to see Frank as well then?"

This will produce "No, he assigns on my recommendation" [Good!] or "That would be a good idea, I'll just see if he's in". This latter means you've been successfully vetted and have gained access to the inner sanctum; the former could mean that as well, or it could mean that you're being brushed off. If I think I've got on alright I simply send a polite note to Frank the next day saying "I was so pleased to meet your Assistant Honcho and look forward to working for you soon......etc" and see what transpires. If I think I've been brushed I give it a couple of weeks and ring up again and this time ask for Frank direct!

Creative Handbook, often found in your local library. If, however, your needs are more specialised, or your library's directory is ten years out of date, you might have to resort to a little subterfuge to get the information you require. There are many ways to do this and here are my three favourite methods:

(a)**The Naive** This is the simplest and most effective method. Simply ring up your client's reception desk and ask who you should contact regarding freelance work in your field. Write down the name, ask if there's a department or extension number you should have, say thankyou and ring off. **Don't** ask to speak to the person now because the receptionist knows what you want and will forewarn your prospect and give him time to think up an excuse not to see you. Instead, ring off and call back a week later and just say "Fred Bloggs please" like he was your old mate and you ring him every day. You'll get through!

(b) **The Information Gatherer.** If you answer phones for a living you'll know that people ring up to collate information all the time. Receptionists are used to these kinds of calls, so if you ring up with a line like "Hi! I'm updating the Bodger & Snodgrass Database, can I just verify we've got this right?" you'll find out all the information you need, like the names and extension numbers of all the various Head Honchos. If you have moral problems about using this one, pacify your conscience by using your own name for the database you say you're calling about. This way you're not telling a porkie when you say that you're updating your own database because that's exactly what you *are* doing! You can even use this method to gather supplementary information like the names of sidekicks or Assistant Honchos.

(c) **The Devious.** If you meet a real closed-mouth company who give

"There is no try. There is only do or not do."

Yoda

nothing away you can always give this one a try. Ring up, and, in your best stroppy Tory MP voice snap "Joe Bloggs Please". The receptionist will, of course, try to find Joe Bloggs and draw a blank. "I'm sorry, we don't have anyone here by that name, what department does he work in?" "He's head art director, of course, I need to speak to him straight away!" The receptionist thinks she's on her home ground now and delivers her punch line to put you neatly in your place. "Oh no, *our* head art director is Fred Smith. *You* must be mistaken!" And you've got what you need. Write the name down quickly, apologise grudgingly and ring back a week later in your normal voice and nail your MAN.

(4) **Know What You're Selling and Sell Only That.** This is the point where many novices come unstuck. They get the background, they make the calls, they get the MAN and then they blow it. Why? Because they try to sell themselves, or their work, or their cheapness, or their experience rather than just trying to make an appointment. Appointment making is now considered such a valuable skill that some large companies actually appoint specialist appointment-makers to do their telephone canvassing. You'll have to do it yourself, however. Remember, as an illustrator, when you're cold calling all you want, at this stage, is to get in the door. That's when you'll do your selling. For now, keep it simple and keep it brief. My own pitch goes a bit like this. I ring up, get the MAN and say "Hi Fred. You don't know me. My name's Max and I'm a freelance illustrator. I'll be in your area tomorrow and I was wondering if you could spare me five minutes to look through my portfolio?"

Note the key points. One, I've made it clear who and what I am. Two, I've underlined that I have a simple request that won't take long. Three, I haven't asked the client to commit to anything stronger than just looking at this stage. The client will now reply in one of these three ways:

The Client's List of Popular Brush-Offs

There are some excuses that are so old cold-callers have standard responses for them. Here are a couple that you're sure to encounter as an illustrator:

1 "Fred's in a meeting at the moment, can I get him to ring you back?" This means that Fred's in the loo or has just sat down with a cup of tea and a chocolate Hobnob and is signalling frantically. Never, ever, agree to a client ringing you back. You will be old and grey, sitting by a mute phone covered in cobwebs and still no further forward. Seize the moment and take control, say "No, that's OK, when will he be free and I'll call back" and ring them back again, and again, and again.................

2 "Send in some samples of work first" I hate this one. Sometimes it's genuine and sincere, sometimes it's just an easy way to get rid of you. You might have heard the old adage "Half the money we spend on advertising is wasted, the trouble is, we don't know which half". The send-me-samples client is like this, half of them are on the level but you can't tell which half. Try "Of course I can, but wouldn't you rather look through my full portfolio, it'll only take five minutes". If the client refuses to budge, admit defeat and post or, even better, hand in some samples. Then follow it up a week later with another request for an interview.

The Positive Client

Client: "Yes, I think I can arrange that. Can you come in at ten thirty tomorrow?"

You: [with diary open in front of you] "No problem at all. See you tomorrow at ten thirty."

The Negative Client

Client: "No, there's no point. We're not using any illustrators at the moment"

You: "Really, why not?"

Client: "Oh, things are really quite just now, the designers are producing anything we need in-house"

You: "I'm sorry to hear that. Tell you what. I'll give you a call in three months' time when things will have picked up, but I'll post you my business card just now just in case you get an unexpected rush and end up shorthanded." Or, in other words, you *believe* in the client. Things are definitely going to improve for him, you've told him so. This client will repay your faith in him by pinning your card by the phone. *Don't forget to post it!*

The Swithering Client

Client: "Well, I'm a bit busy just now......."

You: [with diary] "That's no problem. What's a good time for you and I'll ring you back"

<div align="center">**or**</div>

Client: "Well, we don't really use a lot of illustrators..............."

34

"If you've got them by the balls their hearts and minds will follow"

John Wayne

You: "No problem there. If I could just show you a little of my work so that you've got an idea of my style then you'll know if it's worth taking any further." Useful tag: "It'll only take five minutes!"

<p style="text-align:center">or</p>

Client: "I'm not sure when I'll be free................" He's *really* saying "I don't know what to do"

You: [telling him] "No problem. How does ten o'clock tomorrow sound." And that good old tag line: "It'll only take five minutes!"

(5) And, lastly, **Never Sound Like A Salesman.** Or, to put it another way, never, *ever,* use scripts. From first call to last you should sound fresh and spontaneous, a professional making a professional call. We've all had a call from Mr Dreary, the human tape recorder who robotically recites some exceptionally cheesy script like "You will be shocked and surprised by this wonderful offer". Yeah. And we all know what we think of *him* - **so don't do it!** Keep it brief, keep it simple, and most importantly, sound like *you.*

<p style="text-align:center">How to Talk to the Secretary</p>

When you're Cold Calling, or, as I sometimes call it, 'prospecting', you may spend hours on end being brushed off by secretaries (face it, it's their job!) and many illustrators come to regard them as The Enemy. This is not a good idea. Why? Because *they* hold the key to what *you* want and if they're going to hand it over they'll hand it to their mates and not to their enemies. Makes sense, doesn't it! Anyway, rather than giving you long lists of secretarial dos & don'ts, let me tell you about an expert in the art and you can learn by experience, like I did.

I mentioned temping on a local newspaper. While there I spent a day "on the road" with their motor dealers' rep, a lovely lady named Linda who was

35

"Keep a diary and some day it'll keep you"

Mae West

a true professional in every sense of the word. Motor trading is a man's world and *all* the clients were male and Linda knew just how to pull their strings, just that bit flirty, just that bit coy, and then nailing her sale before the client knew what had hit him. But where, for my money, Linda excelled, was how she dealt with the secretaries. Linda spent ages with them all. She knew them all by name. She knew about their families, she knew where and when they were going on holiday. She even knew the names of their husbands and children. She was their confidant and their guru. They loved her. Their boss might have been their boss but Linda was their *buddy*. Other people might have been repelled at the gate when the boss decided that he "wasn't in", but not Linda, she waltzed right through to the kill every time.

So be like Linda. When you're on the phone or calling at client's offices always take some time to talk to the person at the door. I always force myself to say "Thank you so much for your time" when I'm being brushed-off by a secretary [even when my brain is yelling "Up yours bitch!" at the top of its voice!] because I know that she'll be there the next time I call and I want her to remember me and like me and, maybe, just maybe, next time I'll get through.

So, that, in a nutshell, is Cold Calling. Practice will make it less scary and the key word to survival here is PERSISTENCE with just a soupçon of ORGANISATION thrown in to season the dish. Go out and buy yourself two great big desk diaries - buy them in January rather than December when they've marked down the best ones - and keep one for appointments and one for phone calls. In the Phone Call Diary write out your list of proposed calls for that day (names *and* numbers) and mark your results by each entry as you make your calls (eg, appointments, call-me-backs, sod-offs etc). Before you knock off for the day take a couple of minutes to

Exercise

Just before we wind up our section on cold-calling you might like to try this little exercise which always proves to be fun when I cover this topic at seminars. Many novices at cold calling ask me for help with certain "disadvantages" they perceive themselves as having and I always answer infuriatingly "Turn them into advantages!".

Let's use me as an example. I live in the far North but do most of my business with companies in London and even New York and Tokyo. Disadvantage? No way! When the client hums and haws over an appointment it's so easy to tip the scales in my favour by wheedling "I'm coming all the way from Scotland, couldn't you just spare me *five* minutes?" And they give in every time, bless 'em!

So, amuse yourself. Write down all your "disadvantages" on a sheet of paper and then work out ways to turn them all into "advantages". It's great fun and it'll do great things for your cold-calling techniques!

collate up the information you've gathered. Any appointments will already be in your Appointments Diary. Callbacks should be entered up under the next day's call list, or for the day/time the client said they'd be free. And don't discard sod-offs. Clients change their minds more often than you change your knickers. Enter their details in your Call List for three months from today (don't forget to make a little note about who they are and what they said when you last called - you won't remember!) and ring them up again, and again, and again. At time of writing there's an art director I've been chasing for an interview for over three years but I know that he'll crack before I will! That's the beauty of having a system.

A simple clean-as-you-go setup like this will keep you organised, cut down on stress, *and* generate assignments for you. Work out a system like this one that suits your own way of working - some illustrators prefer to use year-planners or charts rather than diaries, for example - and get it up and running as soon as you start Cold Calling. It's not going to make Cold Calling absolutely headache proof but it *will* help!

40

"I shook hands with a friendly producer once - I still have my right hand to prove it"

Spike Milligan

3

Meeting the Client Face to Face

"An Art Director is the person who separates the wheat from the chaff, and then publishes the chaff"

Anonymous

The Interview and How to Follow It Up

Please don't get uptight about meeting clients face-to-face for the first time. Whereas it *is* true that whether you get the assignment or not often depends on how well you project at the meeting, that doesn't mean that there won't be other meetings or that the world will come to an end if you blow it. Chill. Remember that an interview is just one professional meeting another, or, if you prefer, a salesman making a sale.

Be friendly, professional and, above all, know what you can do for your client and show her the *benefits* of using you and you'll walk away with stacks of work every time. You're still nervous? OK, let's walk through it step by step.

Before You Go

(1) **How to Dress** I only recently came to realise the power of clothes in

"Fashion is form of ugliness so intolerable that we have to alter it every six months."

Oscar Wilde

a client meeting situation. I had been quite happy being a scruff and I quite joyfully skipped all those long, boring chapters in American How To Be A Super-Salesman books where they tell you all about how to, frankly, get kitted up like a used car salesman. Books like these will tell you that this is the only way to look if you want interview success but Uncle Max says not so, shipmates. Ever been in a room full of sales reps? It's a great place to commit a murder in front of witnesses because no-one could pick you out of a police lineup. "He was wearing a grey suit and a Homer Simpson tie Officer!" It's not what I call making a lasting impression.

As illustrators we can, of course, dress any way we want, and that's one of the reasons why we're in the arts after all, we don't want to be part of that great faceless suit & tie parade. And, as most illustration work is done 'offsite', we can work at home in our pyjamas if we want to and many of us do! This being as it may be, however, you might want to ponder for just a moment on your sartorial image when you go to meet clients.

I first became interested in "visual presentation skills" when I went to pick up my girlfriend from an acting class. I was early and I slipped into the back of the room to wait and began to eavesdrop on what was taking place. The instructor had been going over 'Audition Techniques' and was talking at some length about her own "Audition Sweater" a garment that looked like a prop that had been rejected from *Joseph's Amazing Technicolor Dreamcoat* for being too garish. It was a once seen never forgotten jumper and that was exactly why she was using it. Think about auditions from a casting director's point of view. You've auditioned, say, forty actors for a part. Once you've eliminated the truly awful, say about five, you still have thirty five good, capable contenders for the role. How do you tell their performances apart the next morning? Well, you can remember *one* of them, can't you, the girl in the sweater, and that's just put her into a very

44

"A bore is a man who, when you ask him how he is, tells you."

B L Taylor

healthy position.

I thought that this was a terrific idea and decided to review my own interview technique from a sartorial point of view. I had always dressed in good, clean clothes when I met my clients but I had to admit that I looked like all the other illustrators that they would interview. However, what to do about it was another matter. I'm not really the gaudy sweater type and I certainly wouldn't feel comfortable turning up in something that would involve my client reaching for her dark glasses. Now, there was nothing technically wrong with wearing jeans and casual shirts for seeing clients in the art & media industries. In fact, most clients dress like this, but was that a good thing? I decided that as most illustrators go for casual I would go for sharp!

I started going to client meetings wearing a black Armani designer suit to see if it made a difference, and though I'd like to say that my work offers doubled as a result of my new outfit, they didn't. However, it *was* an investment that paid dividends for me in other ways. The first difference that I noticed was with those dragons at the castle gates - Receptionists. Suddenly the "yeah, she'll be down sometime, 'ave a seat!" style of treatment was gone. Now it was "Oh yes, she's expecting you. Please have a seat while I tell her you're here. Would you like a cup of coffee while you're waiting?". In fact, real red carpet stuff. I couldn't understand why design houses were suddenly being so nice to me and then it clicked. The receptionists thought I was a *client*. This was something I hadn't anticipated but when I go up to a desk now I act like someone who wants to buy [ie, a client] rather than someone who has something to sell [ie, an illustrator]. It does open doors, if you can brazen it out, and it's a great way to get in places without an appointment!

Hot Tip!

When just about to go into a meeting with a client, make sure that you're carrying your portfolio in your *left* hand so that your right hand is free to shake hands with the client when you walk in the door.

It might sound a bit like advice from one of those awful American power-selling books, but there's nothing more flustering for starting a meeting than being unable to return a handshake, dropping your portfolio and then falling over it!

The outfit is also slowly having the desired effect with commissioning Honchos. It hasn't been earth-shattering but over the last two years since I changed my look I've noticed a very slow increase in responses from new 'potentials', so the 'Audition Sweater' has worked for me. That doesn't make it mandatory. You're a freelance. Dress the way you want to dress and leave the dress codes to the drones. But use your head. If you can't exist in anything but a T-shirt that's great, but why plug the Suga Babes when you could be using it to promote *you*. A client's going to remember the freelance who had "Joe Bloggs illustrator" writ large across his chest . You can produce it yourself with a plain T-shirt and your Mac's printer, or your local copy shop will create a 'professional' one for you from your artwork for about ten quid. Think about how you look and then compare that to your competitors. That's what supermodel Linda Evangelista did when she decided to adopt her distinctive fringe. Is there some *little* thing that you can do that makes *you* stand out from the crowd?

When You Arrive

(2) **What Do You take With You?** This is a question that I am asked time and time again. The answer is a simple one. Take yourself plus something to show them and something to leave them or, in other words your portfolio for them to look through while you're there and some samples and a business card for them to look at after you've gone. You might find it easy to use what I call the **Meetings ABC**. When you go in present the client with Exhibit A - you. Shake hands, introduce yourself and exchange a few pleasantries. Don't mess around at this stage, but move quickly and seamlessly to Exhibit B - your portfolio. Get the client settled behind her desk, open your folio and talk your client through your presentation.

I always go on at great length about this at seminars and bore everyone to

48

"I have always regarded the telling of funny stories as the last refuge of the witless, the supreme consolation of dirty-minded commercial travellers"

Nathaniel Gubbins

tears so I'll only say it once here. **TAKE CONTROL**. There is no point in the client siting in her own little corner flicking through your work while you sit dumbly in yours letting her. You might as well have sent it through the post if you don't gain anything from being there. To see how it's really done watch a good double glazing salesman in action. He *could* leave you a brochure telling you all the benefits of his system but he doesn't. He walks round your house with you and tells you how he would transform each window. He paints a picture for you. He answers your questions. He makes sure you've got the point. And that's what you must do.

Emphasise all the salient points that you want your client to take in. My old school teacher used to always say, "treat the examiner as an idiot, boys, assume he knows nothing", and that's exactly how I treat my clients when I'm making a presentation. It never does any harm to state the obvious now and again, so say what you think needs to be said. Have you ever been to an "illustrated talk"? I once attended one given by a mountaineer who'd been up Everest. He showed his slides, he illustrated points of geography with maps and diagrams, he brought the expedition to life with anecdotes and funny stories.

This is how you should show your work. Guide the client through it. "This is a poster campaign I worked on for ICI". [You've told her you have experience with major league players] "This is a package design I came up with for Unilever which I thought would be a good approach for your Bodger's brand" [Now you're not only experienced but you've researched her products as well] "This is a piece that old Bob Kingly at Leo Burnett commissioned. His dog ate the first effort so I had to do it again with only four hours to deadline!" [This funny story helps to give a human touch to the work, plus it shows that you can cope under pressure - god, what a professional you are!]

Hot Tip! - Third Party Commissions

If you land a job from a design agency or other third party, try and find out as much about the actual commissioning client as you can.

I was once given an open brief commission from a design company to create humorous greeting cards. I got all the technical data from them but didn't think to ask who *their* client was, and put together a batch of cards with jokes like -

Grand-daughter: "Do grown-up ladies have sex with their husbands Granny?"

Grand-mother: "Only when there's no-one else to have it with darling."

These were really popular and *my* client said that they loved them but none of the designs ever saw print. Why? Because the final client was Marks & Spencer.

Always find out who's at the top of the food chain!

This is how I handle my presentations. I treat them like showing my holiday slides. I want people to live the holiday with me but I don't want to be the office bore and put them all to sleep. Nobody cares what I had for breakfast *every* day of my holiday. The white-water-rafting story and the pictures of the busty blondes from the disco are far more interesting. Keep it relevant, interesting, funny and *brief*! By all means talk about the work and how it was produced. Make sure that you tell the clients how something could be adapted to suit their needs. Throw in at least one or two funny stories to keep the meeting buoyant, but don't, don't, don't go on and on. Don't tell the client about all of your children and all of their names (unless, of course, he asks!), and don't get into a lengthy account of how someone wronged you or failed to appreciate your talents. Never, ever, run down another client or give away business secrets in an attempt to gain work. No-one trusts a spy and any assignments gained this way will be of a strictly ephemeral nature.

Now bring the presentation to a close. Answer any questions the client may have and make ready to leave. If no offer of work has been forthcoming present Exhibit C - the stuff you're leaving the client, or what I cal the Party Bag. Your Party Bag should always consist of your business card plus any samples of work that you're leaving behind. If humanly possible, leave something that the client can put on her wall or memo board - you won't be doing much selling from inside a drawer or filing cabinet. A business card or post card with your most famous or striking image on it is great, or maybe you can run to a calendar. Most DTP software has a calendar template and it's fairly easy to add your name and number and a nice image. If that's too sophisticated/expensive you can buy calendar tabs and hangers from a craft shop and create a calendar from your business card or photograph.

Hot Tip! A Word About Contracts

I don't personally use contracts with established and trusted clients but believe strongly in having one with either unknown entities or art directors who have messed me about in the past.

If you want to create a contract don't go to your lawyer for advice but instead go to a professional association like the AOI. They will usually be able to provide you with a standard contract and will certainly be able to tell you what you should include if you're writing your own. Why pay a lawyer if you don't have to?

Contact the AOI at:
The Association of Illustrators, 2nd Floor, Back Building,
150 Curtain Road, London EC2A 3ER.
020 7613 4328
www.theaoi.com

Be inventive, be imaginative. Do what it takes to stay under the client's nose. If you have money to play with look at business gifts. A mousemat with your artwork and name on it is a great investment, for example. There are catalogues of stuff you can buy, but take care. Not only are these considered pretty non-cred in the Design industry, but something like a keyfob stays in a client's pocket and doesn't stare him in the face - stick to things that will stay on the client's desk!

And then.................

...........ASK FOR WORK. Never, ever, leave a meeting with a client without asking for work. Now I can hear your knees knocking and your teeth chattering from here, but, honestly, like Cold Calling, this is no big deal. I usually say something like "Have you got anything for me just now?" or "Is there anything in the pipeline that's in my line?" It takes all of two seconds to say and it's often the difference between getting an assignment or not. You've heard the phrase "if you don't ask you don't get" I'm sure it was coined by an illustrator about his client meetings (and if it wasn't it should have been!). I don't know why this should be, but many clients simply won't offer you any work unless you ask for it. So ask for it.

(3) **When to Mention Money** You've clinched the deal. The client loves your work and an assignment is on the table. It's time to mention money. Some illustrators have a standard contract of terms already written up which they produce at this stage.

If you haven't fixed up a contract yet, employ the opening line. "So, what'll you be paying me?" I find that this approach helps to cut out some

"The only people left in America who seem not to be artists are illustrators."

Brad Holland

of the stages of what must be freelancing's biggest pain - the Money Minuet. This is the name I give to the ritual dance where you and the client skip towards a sum and then away again, twirl around several times, bang your stick with bells on it, and then skip back again before a figure is eventually agreed upon.

This is a really irritating process, especially since most clients already know what they want to pay you anyway. They just go through the ritual of asking in the hope that you'll offer to do the job for less. Likewise, you don't want to quote a sum first because you're scared that the client might be willing to offer more than you ask for.

It's a nightmare process, but *always* corner the client into naming a sum first. The client will, of course, be trying to get you to name the first sum, and, if you find yourself in the corner, try saying "What budget is available for this project?". This forces the client to bring some figures into the game. Remember, you don't need to go for what the client offers first time if you want to chance your arm, and it's considered OK to say "Please sir, I want some more" at this stage of the ritual. For example, if the client has quoted, say, five hundred pounds as her suggested fee you can try, "Well, that's a bit tight...... I'd really be looking for something around the seven-fifty mark", and see if you can get six hundred out of her.

If the client's not going to budge and you want to do the work, give in as a "special favour" to the client and take the deal she's offered. You did your best, after all! Of course, sometimes you'll hit companies who pay fixed rates for work and you won't have to bother with any of this. Many magazines, for example, have fixed fees that they pay for covers, spots etc and a take-it-or-leave-it attitude, whereas design and ad agencies will never, ever, quote a price first. If *you* hit clients like this and are forced into

Hot Tip!

Every time you've been to a work-generating meeting with a client, whether you got any work or not, it makes a great impression if you send a brief thank-you-for-your-time letter or card, and pop your business card in again. It's a tiny detail, but it can often be the difference between you and the other guy!

quoting first, always add a couple of hundred onto the price you'd like to get to allow for the client trying to beat you down. Some illustrators print up little cards with their rates on them but I've yet to meet a client who would fall for a stunt like this. If, like me, you feel dubious about fixing your prices, grab what you can get and simply use the high-paying assignments you get to subsidise the - sometimes more interesting - lower-paying ones.

(4) **Knowing When to Leave** Now it's time to go. The client likes your work. She's given you an assignment, after all. You've talked money and agreed a fee. If a deadline date hasn't been mentioned yet, ask for it now and write it down *before* you go - and then get the hell out. I've seen so many illustrators blow their chances of lasting relationships with clients by being unable to spot the door the client is showing them and walking through it.

The client is busy, that's why she's calling in your services. She has other things to do. Right now you're her number one gal or guy because she's just put an assignment into your capable hands and it's one less thing for her to worry about. Don't blow this confidence by standing around yakking and adding to your client's stress points. She won't thank you for it and, worse still, she'll think twice about inviting you back.

Get out while you're still on top.

(5) **Delivering the Goods** RELIABILITY is a word that you'll quickly learn the importance of in successful illustrating. As many would-be's have learned to their cost, a mildly competent freelance who always delivers on time will fare far better than an astoundingly talented one who doesn't. You may have all heard the stories of 1950s illustrator Anthony Grove-Raines

58

"Some are born great, some achieve greatness, and some hire public relations officers."

Daniel J Boorstin

who never met a deadline in his life and was so popular he was never without work, but he was the exception rather than the rule.

Never, ever, take on a job without first ascertaining the deadline and never accept the job if you don't feel you can do it in the time available. When I get together with my illustrator chums we all talk shop but we don't talk about art - like most illustrators we complain about money and our lack of it, and always conclude that the client's ideal illustrator is a QC - quick and cheap! Now, if you want to use illustration to make a packet and you're a good hard-nosed negotiator you can get over the cheap bit, but there is no escaping quick! Illustration deadlines tend to be short and sudden. When work needs to be done yesterday the client turns not to his photographers but to his pool of specialist miracle-workers to bail him out. That's you and me, by the way, and that's why it's vital to make sure we always honour our promises when we jump onto our white charger and gallop to the rescue.

However, take care not to be *too* helpful to your client. I like short deadlines and always leave work to the night before even if I've had a week to do it in, but if *you* prefer to get your assignments done in advance please don't fall into the Novice's Trap and be a boy scout. By this I mean that if the job's wanted for Thursday don't try to earn Brownie Points with the client by handing it in on Tuesday. All this does is give the client three whole days to pick and prod at your work and find things that she wants changed or redone and you'll end up not only doing twice as much work for the same money but also finishing up with an image that is totally different from the one you originally conceived. Deliver it on the day it's wanted and you automatically eliminate this problem.

Also, where possible, if you're hand-delivering physical artwork, try to deliver the job into the hands of the person who commissioned it. Never,

Exercise

A fun way to get awesome work is to make up some lists. Have a fantastically self-indulgent time making a list of your ten favourite bands of all time. Then ring up their record companies and ask to illustrate their next CDs.

Do the same with your ten favourite authors and then ring up their publishers. Or how about your fantasy portfolio? Make a list of all the jobs you'd love to display in your portfolio then ring up and try and get them.

Have fun. Get great work.

ever, leave work with reception desks or security lodges unless you've OK'd it in advance with the client. Remember that unless there is a recognised procedure in operation, work left with gatekeepers tends to stay at the gate until somebody comes looking for it and I could spend hours telling you horror stories about work that was "lost" for eight days under a reception desk while the illustrator and the art director ripped their hair out.

All this being put aside, however, the real plus point to getting your work into the hands of the person who commissioned it is that you might, just might, land another piece from them. So, what do we do when we deliver our work? All together now - *ask for more!*

61

Hot Tip!

Do you move about a lot? I only tend to stay in one place for about four years before I feel the urge to move on. If you're like me make sure that your mobile number and email address are prominently displayed on your business card, so if your land line number changes clients can still get in touch with you.

Another option is to buy an 0870 number which becomes a number for life. But have a care, I bought one of these and received a letter a couple of years later saying that the company had gone bust and the new owners now wanted seventy quid a year rent from me for the number I had bought "for life"!

Another way of looking at this 'problem', of course, is that every time you change your contact details it's a great excuse to contact your client by phone and letter and, of course, take the opportunity to ask for work!

4

Self-Promotion: Setting Up & Using a Personal Database

"I must create a system or be enslaved by another man's."

William Blake

Creating Your Database

OK, you've made the calls, you've met the clients, but the work you wanted hasn't rolled in. It's a pain in the rear end but a fact of life that work doesn't always appear just because you've met the right people and you'll need to set up a system that both generates new 'leads' and keeps you fresh in the memory of those clients you've already met. To do this you need to set up and run a **Database**.

Now a Database is just a fancy name for a big list of names and addresses, and the trick to efficient database running is knowing how to transform all the miscellaneous information that comes our way each day into an accessible and, therefore, work-generating, body. Even if you have only been illustrating for one day you will already have material for a Database. For example, if you have made a wish list of people you'd like to work for that's the start of your Potential Client Database. If you've called three people on that list that's the first stage of your Operational Database in

Hot Tip!

If you're a Mac OSX user your Mac's **Address Book** sofware is excellent for compiling and maintaining your database electronically. And it's free!

For details on putting Address Book to use see your Mac's manual or consult **"Mac OSX - The Missing Manual"** by Mac Guru David Pogue (Pogue Press)

action. If you then land a commission from one of those three that's one name to go onto your Established Clients Database.

Once you've got all your client information 'in stock' you can decide how to put it to work and instigate contact programmes that will keep your work-flow fluid. For example, we were talking earlier about setting up and using a two-diary system for calls and appointments, that's a perfect example of a simple Database in action.

So What Should My Database Look Like?

As you have no doubt already guessed, your Database can be a simple address book or a shoe box with index cards or a computer. All are equally effective if you commit to using them, and, unless you already have a Mac, don't even think about buying one just for your Database until it's numbering well into the hundreds. What really counts in a Database is not how your information is stored but how you put it to work. There's no point, for example, in having a list of a thousand names on a swanky software system if you never contact them. However, if you were to sort your contacts into, say, **Interested**, **Not Interested** and **In the Middles** and instigate a programme for contacting each group on a regular basis, then, suddenly, you'd have an efficient working Database that's bringing in cash.

So, "let's start at the very beginning" and walk through the setting up of an elementary Database which will soon generate work and start earning you money. The best starter method is the old tried and tested shoe box and cards system, so, find a shoe box and then go out and buy two packs of index cards (one white, one coloured) and a pack of dividers. Right, we're ready to create a Potential Client database. Write the client's details on the front of a coloured card. I put company name and contact name first, phone

Hot Tip! - Stock Libraries

Stock illustration is a term that all illustrators have come to loathe. Instead of bothering to commission the correct piece of art for a job the client simply buys an off-the-peg image from a library. Philistiens!

Of course, from the clients' point of view, stock makes sense. It's quick, it's cheap, and it doesn't miss deadlines or expect a card on its birthday. From our point of view, however, it's a death knell to our industry.

So what do we do about stock? Boycott it? Petition our clients not to use it? Picket the stock-men's offices?

Frankly, we'd be pissing in the wind if we tried. Stock, whether we like it or not, is here to stay. Our job, as illustrators, is to be so reliable, so professional and so down-right brilliant that clients can't resist using us. Remember, whereas stock can be used quickly and cheaply for run of the mill jobs like Business images (there are millions of Bulls & Bears images in stock, not to mention men in suits shaking hands!), there are hundreds of *unique* concepts that *cannot* be illustrated by photographs or stock images. For example, during the Bill Clinton & Monica Lewinsky scandal I received no less than three commissions for Monica images from editors who didn't want boring old stock or *Paparazzi* shots.

See also: **Illustrating for Stock** on page 68

number second, address third and then any extras like fax number or email address on the end. (You can use the back of the card to record each call you make with dates plus any important notes like "plays golf Thursdays" or "secretary's name is Diane, three kids, husband in shipping" etc.)

Now make out a card for every potential client you have. Start with your original list of people you'd like to work for and then just keep adding to it. This is an ongoing process that never stops. Trawl for 'leads' everywhere. I haunt newsagents and book shops and put the name of every magazine that uses illustration in my *Potentials* Database, plus every theatre producer, every book & card publisher, and every record company. I also check the design credits on all the books & CDs that I buy and look up the design company's address to add to my Database of Potentials. I keep all the potentials on coloured cards until I have made some form of personal contact with them, usually a meeting, and then their details are transferred onto white cards which form my *Clients* Database.

OK, you get the idea. Now file your cards according to how you want to work. If you're just starting out allow *at least* an hour daily for Cold Calling new potentials and give yourself a dozen a day target, so put your potential clients into batches of twelve. You can use desirability or geography to batch your clients. If you live in Leeds, for example, it probably makes sense to batch together clients in Bradford for one day, Huddersfield for another and Manchester for the third day's calls. Alternatively, batch together the clients you most want to work for and call them first, then do the wouldn't minds and finish with the don't cares.

To cut a long story short, what we're trying to achieve here is a system which backs up your personal work pattern. For example, I enter new potential client details on coloured cards and the details are used in my

Hot Tip! - Illustrating for Stock

OK, so stock's here to stay. As we can't beat the stock-men, do we join them?

This is up to you. Many illustrators feel that stock is the enemy of commissioned work and that if we refuse to supply the stock-men with images we will effectively put them out of business.

Others feel that if illustration money is being paid out for stock we should claim our share of it. On a personal note, in 1999 I supplied some images to the Stock Illustration Source who were very nice, helpful people who did a lot to promote my work, but at the end of the day I paid SIS about £600 to have trannies made of the images I lodged with them and, seven years later, have only seen about £100 back in fees, so draw your own conclusions.

The trouble is that the stock-men store thousands of images and only care about making a sale, not making sales for you. If you really must create stock images it might be a better investment of time and money if you have them put onto a high-resolution CD-ROM and sell them yourself to clients who like your work but can't or won't commission you.

Remember, though, every stock sale is at the cost of a commission!

daily call sheets until I've established a firm contact, preferably a meeting. Client details are then transferred onto a Mac Address Book Database which has replaced the old white cards and previously contacted clients are batched into call batch order so that they can be recontacted twice yearly by letter and three times a year by phone. In addition to these personal contacts they also receive a monthly e-newsletter, 2 or 3 postal newsletters per year, plus a card at Christmas. (More on this later)

This system not only keeps me in constant touch with my clients, but also runs as a self-cleansing Database, since thrice yearly phone contact automatically updates job and address changes and subsequently keeps the list fresh at all times.

So how will you use your Database? Think about how often you need to be in touch with clients. If you think you need two commissions per week to survive then working on the one yes for every seven noes principle you must ask *at least* fifteen people (and preferably more!) for work every week to produce the results you want. There's no point complaining about your lack of commissions if you haven't been out asking for work *this week*. Just because you spoke to a client three months ago doesn't mean that she still remembers you today. Clients see *hundreds* of illustrators in an average year. Set up a system and contact your clients again and again and again - if *you* don't someone else will!

Database making is a process that never stops. Utilise the data which is all around you to create leads. Ask your clients when they need your services most and organise your Database to remind you of these dates. Trawl the places that work like yours is used, and try the trade press and the business columns of your local paper, they're a rich source for finding clients who'll need your services. If you provide illustration direct to businesses and not

Art Reps - A Good or a Bad Thing?

There comes a time in every illustrator's life when she feels that she's gone as high as she can go but there are still unclimed summits on the horizon. It's usually at this time that our thoughts turn to art reps or artists' agents.

So, are reps a good idea? The best answer I can give is, it depends. Personally, because reps can't sell my off-the-wall illustrations to advertising agencies they usually don't want to know me. However, having said that, I've met some really decent, hard-working reps who have been very respectful of my work and not made me feel inadequate or inferior when they declined to represent me.

On the other hand, I've met some lazy inefficient blood-suckers who I wouldn't entrust my shopping at Sainsbury's to, let alone my my creative work.

So, as an unrepresented (and therefore biased) illustrator, I can only say - check them out. Does the rep understand you? Will she get you the kind of work you want, or will she try and bully you into doing the kind of work she'd like you to do? What commission will she take? When will you get paid? What costs will you have to meet? Is advertising under the rep's banner on websites and/or illustration directories compulsory and, if so, what will it cost? Will the rep take commission on jobs you find without her?

And, most important of all, do you like her? And does she like you? If you don't get on you won't be able to work together.

See also: **Art Reps, How to Find Them** on page 72

just through design companies watch for announcements in the press & around you of new business openings and then put them into your Potentials Database and get in touch. There is an abundance of work out there just waiting for you to discover it. Pamper your Database by finding it lots of juicy new possibilities and it will reward your diligence with lots of lovely assignments.

I'll Feel A Fool Making Second and Third Chaser Calls to Clients What Do I Say?

The Americans have a great way of opening calls like this. There's a guy in New York who sells me directory space who always starts with "Hi, it's John from *Showcase*, I'm just calling to touch base........" which I think is a tremendous opening, even if the words do sound a bit weird for us staid Britishers. Like any other form of telemarketing, of course, there are various different approaches that we can employ when we repeat-call clients.

The first is the straightforward **Courtesy Call**. This is exactly what it says it is. You just ring up and say something like "Hi, it's Max. I'm just ringing to touch base / let you know I still exist / keep in touch etc". Big companies like British Telecom favour this approach and you've probably had a Courtesy Call from BT at some point in your life.

If you don't feel comfortable with the standard Courtesy Call you can revert to the second version, the **Pretext Call**. In simple crystal mark English, this means that we dream up a pretext to call the client like "Hi, it's Max. I'm just ringing because I've just finished a piece of work that I thought you'd be interested in and wondered if you'd like to see some samples" or "to give you my new email address" etc. I personally prefer the pretext call because

Art Reps - How to Find Them

OK, you've decided that you want a rep. How do you find one? There is a school of thought that reps are mythical creatures who will appear out of the mist one morning bearing a golden pen on a velvet cushion when you are artistically ready for them.

This may be true, but if you're too impatient to wait for this to happen go to the AOI or ask other illustrators for the names of agents. Then look them up in illustrated directories like **Contact** (www.contactbooks.com) or websites like the **i-spot** (www.theispot.com). Does the rep handle work that you would want to do? Does he specialise or is he very general? If he's general will you fit in within his existing stable of illustrators? Does he have hundreds of illustrators? Will you get any attention or will you be lost?

If all seem well ring up and ask if he'll look at your work - remember, at this stage that's all you want. Try and get an interview straight away but the rep might not play without viewing samples first. If he's happy with your samples insist on an interview. Never, ever, sign with a rep without meeting them and seeing their office. Don't accept meetings in coffee bars - make sure there's an office where you can find the rep if things go wrong. Remember, if you sign with a rep they will collect **your** money on your behalf - make sure you know where to find them if you need to collect it.

Likewise, have the AOI or GAG check out any rep's contract *before* you sign anything and get a contract that gives both you and the rep a three or six month trial period. A friend of mine signed with a rep who turned out to be duff and had to work under a pseudonym for five years until his contract granting the rep exclusivity had expired!

I feel phoney using the courtesy call method. I'm also paranoid and have convinced myself that my clients will all hate me if I ring them up for nothing in particular, even though I *know* that this is completely untrue. [Pathetic, innit!] However, in a feeble attempt to cover up my own rampant cowardice, I will add that the Pretext Call *is* a double-whammy call because it gives you the opportunity to follow up with a letter and, in effect, have two pitches for the price of one.

And, of course, what do we always do when we ring a Client Database client? All together now, *we ask for work!* A typical Pretext Call should run something like this: "Hi, it's Max. I've just done a new job that's really up your street, would you like some samples? [Client says OK] Great, I'll put them in them in the post now. So how's things at your end, any wonderful projects that you need my inimitable talents for?" and, hopefully, the client will say yes.

Now, if all that seems a bit long-winded for you, your best bet is the third option - the **To The Point** call. This is basically what it says it is, "Hi, it's Max. Just calling to see if you've got any work for me this week!" This is a really effective and fast way of keeping in touch if you've got the stamina to carry it off. I force myself to do this when I'm pushed for time or if I've run out of pretexts and I always promise myself that I'm going to do all my calls like this in the future because it's so easy, quick and painless. A sort of feel the fear but do it anyway sort of calling, if you like. It sounds scary, but, please, be braver than me and try to use it for as many of your calls as you can. You can, if you prefer, mix it with the double-whammy element of the pretext call if you don't get any joy and conclude it with "Well, no problem, I'll pop some new samples into the post for you while I've got your address in front of me!" What client could resist?

How to Run A Happy Database

1) Keep in regular contact with all your clients by phone according to your career needs, but at least three times a year

2) Contact all your clients with a Hi There! letter at least twice a year.

3) Always enclose your business card when you write so that it goes back to the top of the client's stack.

4) Always try to enclose something that can be pinned to a wall with your mailing.

5) Christmas and other holidays are the illustrator's opportunity festivals. Always send all your clients a personalised card.

6) Use payment as an excuse to contact the client again. Have a little note saying something like "thank you for your cheque - please call me when you need my services again" and send it out every time you get paid. Likewise, use your invoices to canvas for more work. Always end them with a "thank you for your commission and looking forward to your continued patronage" type of thing or actually feature an ad for yourself on your invoice.

Contact By Letter

You can back up your regular phone contacts with your Client Database with written reminders of your existence as well. In addition to straight publicity mailings like Newsletters you can effectively mail your clients with **Hi There!** Letters. The beauty of the *Hi There!* letter is in its simplicity. You can use it to say whatever you want with maximum brevity. Hi there, have you checked out my new website? Hi there, do you have any work going? Hi there, I'm giving all my favourite clients a twenty per cent discount this month, etc, etc.

Hi There's are brief and direct and they let you keep in constant touch with your clients without ringing them up every ten minutes, *plus* they give you the opportunity to send your clients your business card again and thereby put it back on the top of the stack, *plus* refresh any samples that you left with them the last time you called.

Christmas Cards

Lastly, never miss out on Christmas and other card-sending holidays. Always ensure that you send a Christmas card to all your clients thanking them for their patronage and looking forward to their continued support. You can actually say something like this if you want or just stick to "Merry Christmas" - after all, the gesture of sending a card says it all. I always design my own cards and, rather than order a huge print run which would probably last me several years, I have the design photographed and put onto self-adhesive prints by a firm in Cornwall who also supply card blanks which I have my name and number printed onto. (If you can't run to interior printing you can cut corners by getting little stickers printed up to display your details and some suitably festive graphic for only a few pounds.) I

Hot Tip! Contracting Out Your Print

These days it's very tempting to design all your own publicity material on your Mac and print it off yourself, particularly if you own a heavy-duty laser printer. This is OK for short-run items but for a major leave-behind item like a business card it's still preferable to have it professionally printed.

There are loads of colour printers out there but check out a firm called **RCS** who have done all my publicity material for the last five years. They're a great self-service outfit. Do all your own design work in whatever programme you're happiest with, (they'll take work originated in everything from Quark Xpress and In-Design to Microsoft Publisher), then send them a disc or upload your original via their website and a few days later a box of top-notch print will be on your doorstep for a minimal investment of ready cash.

For a free catalogue and samples, contact RCS at:
RCS plc
Randall Park Way, Retford DN22 7WF
0800 328 5064
www.rcs.plc.uk

76

know that this method is now a bit old fashioned, but I still prefer the image quality to using photo paper on my ink-jet printer and doing the job myself, but by all means go for it if you want to be totally independent here.

Christmas cards sometimes show tangible results and sometimes they don't. A client of mine who hadn't used me for over a year rang me this January with a commission for a piece of regular work after receiving a card. But even if there is no visible response worry not, clients *always* appreciate the gesture of being sent a card and *do* notice. Honest!

"There is no bad publicity, except an obituary notice"

Brendan Behan

5

Self-Promotion:
Publicity & Advertising (That Costs You
Money…..)

*"Fame is a shuttlecock. If it be struck at one end of the room, it will soon
fall to the ground. To keep it up, it must be struck at both ends."*
Dr Johnson

Your Publicity Campaign

The first step in our formal publicity campaign should be to decide on our
Image. We touched on the subject of image earlier when we were
discussing how to dress when meeting our clients. The way we look is, of
course, an integral part of our image and if we project, say, the image of the
suave and sophisticated artist over the phone and then turn up for a first
meeting looking like we've just been pulled through a hedge backwards we
will lose ground with our client.

So, let's start blocking out our publicity campaign and pick an image for
ourselves. How do want your clients to see you? Do you want a
conventional image? For example, most creatives usually opt for genially
scruffy but efficient, but you might prefer to create an image for yourself
that's contrary to type, and there's plenty to be said for zagging when the

Hot Tip!

Some people prefer to recycle envelopes & paper for environmental rather than economical reasons. More power to you!

But, if you do this with your business mail then make what you're doing clear to your clients and design or buy some of those stickers from Friends of the Earth which say **"This envelope is recycled to save trees"**.

This way your client knows that you are a conscientious green and not some dubious cheapskate.

rest of the industry is zigging. So, if you want to be either the sharpest illustrator or the scruffiest then go for it. It's your career.

However, as we mentioned earlier, many of us seldom or never meet our clients in the flesh so how we dress may have very little to do with our image. Therefore our telephone manner and our stationary must speak for us instead. A client will most probably be unimpressed by a freelance who phones up claiming to be, say, a topnotch digital whiz-kid but who stutters and mumbles and constantly gets all their facts wrong. Likewise, notepaper speaks volumes about us. A friend of mine recently sounded out the possibility of starting a magazine and advertised for freelance writers & illustrators to contact her with samples of their work. This produced a motley crew of strange and recycled envelopes, odd pieces of old toilet paper and material written on typewriters that looked as if they had been stolen from the Olivetti museum. She was totally unimpressed by the standard of work that she was offered and admitted to being put off some freelancers *before* she even looked at their material simply because their poor stationery and semiarticulate letters made them look like such rank amateurs.

So, what is your stationery saying about you? Does your letterheading and business card say dynamic, professional and reliable or does it scream weird, amateur and cheap? I'm not asking you to be Mr Toady of Bootlicking, but clients are only human. They will be put off, like you would be, if you don't go out of your way to woo them correctly.

Now, before we go any further, please, please don't get paranoid about your business stationery and go and take out a second mortgage for state of the art printing. As long as all letters and written pitches are sent out neatly written or typed on clean white A4 paper and, preferably, in envelopes that

Hot Tip!

Always check the spelling of names on all your mailings. Nothing is worse for alienating a potential client than getting her name wrong on first contact.

Worse still, starting letters addressed to female clients with "Dear Sir" is not going to make you flavour of the month either. I am reliably informed, for example, that Maggie Mundy, who runs the Maggie Mundy Illustration Agency, will bin pitches from artists who address her thus - and there seem to be plenty of very careless would-be's around who appear to do just that.

Don't join those ranks, take a little time over your addressing and reap the rewards that you deserve.

don't have *Readers' Digest* printed on them, you've no need to worry. In fact, if you don't have a Mac or you can't afford decent printed note paper plain paper will look much more professional than something you had run up for three ninety-nine out of the *Exchange & Mart*.

It needn't cost a fortune to project your image. As an illustrator it's best if your business card conveys this with a picture of your own making, but if you can't afford this straight away, don't fret, print a card off from your Mac on glossy photo paper or card or just go for a plain card (you can always add a sticky photo print!) with your name and phone number on it and avoid any art not by you unless it's some very basic symbol like pencil or a paint brush.

Remember, you are asking clients to invest in you. Would *you* put your own money into an investment plan that arrived in a tatty envelope with your name and address written in wax crayon and spelt wrong? Stay calm, there is only one hard and fast rule to remember when sending out written or printed material. You don't need to grovel to clients or forsake your principals, and you can be as environmentally friendly as you want. (In fact, I've seen some brilliantly conceived design which uses only recycled materials.) The only thing that you **must** remember is that anything you send clients must look professional and project the image that you want it to project.

Adverts and Directories

OK, we've done image, you know the 'look' you want to cultivate and your appearance and print back it up. Now it's time to start the 'formal' publicity campaign that will get the phone ringing and bring you in some business.

Hot Tip!

You will get the best value out of directory space if you wait until you create an image that becomes famous or well known. Clients respond to the familiar, and a recognised image will generate lots more business for you than a previously unseen one.

John Bergstrom, a former rep of many years standing with **American Showcase**, adds: "The best advertising is to get a great campaign or have an article written about you or win a competition"

One of the first things that you'll probably come into contact with when you first start out in your illustration career is an industry directory where, for a fee, you can display your name, phone number and an example of work in a reference book which is mailed to arty decision-makers. From experience, I can tell you that the temptation to be in one of these volumes will be great. The people who sell space in these publications are masters at their art. You will be painted a roseate portrait, via glowing testimonials, of a phone that doesn't stop ringing and queues of desperate clients beating on your door with wads of fivers clasped in their clammy fists. You must advertise, the sales reps cry, if you are to survive.

Maybe. Maybe not.

I'm not against illustrators' directories and their matching websites. In fact, some clients use them almost constantly and many illustrators pick up quite a bit of business from them. It sounds like a good gamble, I must admit, but before you rush off to get your cheque book just pause for a moment and think about what you actually want your advertisement to achieve and then ask yourself if it can feasibly generate these results for you.

This is where we encounter the **First Myth** of the Directory Rep. "Once you are in the directory work will just pour in without you having to do any other promotional work". Sorry, not true. Directories are good but they're not that good. Many a shy freelance has handed over large sums of money because some rep has assured him that he need never cold-call again, and been bitterly disappointed. Yes, a directory entry will generate some business, often quite a lot of business in fact, but it will *never* be a substitute for Cold Calling. Sorry.

Hot Tip!

This seems like an appropriate place to tell you a secret that all my buddies in telesales will hate me for. **Never trust a salesman.** I know that they all seem hardworking, honest, affable coves, but they are Salesmen first and foremost and, in truth, are nothing more than pariahs in cuddly clothing.

They know our weaknesses and they prey upon them. They know that we illustrators are lonely, solitary souls and that what we all crave is feedback [ie, praise] for our work. So they enthuse about what we do. They are our number one fans. They will lavish unending compliments upon our heads and, what's worse, they will often be at least ninety-five per cent true.

Enjoy. Lap up everything they give you and then put on your hard heart and base your decision to buy or not to buy on **proven facts** only.

Second Myth. "The directory will reach all your clients". Only if you've done your homework. As a young and eager freelance I paid out over seven hundred pounds for an advert in a major creative directory and *didn't get a single response*. I suffered from the loss of money, of course, but, more importantly, my self confidence took a kamikaze dive. My work, I reasoned, must be of very poor quality indeed if no-one was even bothering to ring me up and ask me to do a cheap job for them. In fact, I got so demoralised that I almost contemplated quitting the business. Luckily for me, however, I didn't stop Cold Calling and work was coming in from that source which made me question the veracity of the nonresponse I was receiving from the directory. Clients who actually saw my work were commissioning me, so why weren't the ones who were seeing it in the directory doing the same? I began checking out the bookshelves in clients' offices as I trawled my portfolio round and discovered an interesting fact. The directory that I had advertised in was notably absent whereas the publication of a rival firm - **Contact** - was everywhere. I had backed the wrong horse.

So, my advice to anyone contemplating using a freelance directory is "surround yourself with the facts". Don't take reps' word for things. Go out and prove them to yourself. Ask your clients what directories, if any, they use. Look for the evidence on their shelves. Is the directory there? Is it this year's? Is it battered and covered in annotations or is it still pristine in its shrinkwrap? Be ruthless in your investigations. Leave no stone unturned and, at the end of the day, draw your own conclusions.

Lastly, if you do decide to go with a directory, ask the rep to give you a free classified listing before you part with any cash. Ninety-nine per cent of all advertising sales reps can do this for you, even if some need a little coaxing, and it's a great way of trying the water while you go out and do your

"Since multinational giants couldn't have little pictures of red barns or weeping clowns in the lobbies of their Bauhaus buildings, Abstract Expressionism emerged as the world's most overrated form of interior decoration."

Brad Holland

research. In fact, even if you've decided that directories are not for you, it's a good idea to clock up as many free entries as you can. Like Tesco's, every little helps.

Trade Papers & Magazines

Another erstwhile contender for a slice of your publicity budget is the trade press, and, like professional directories, advertising here can reap great results if you do your research and place your bets with care. A word of caution before we proceed, though. I took myself to the brink of bankruptcy over advertising in trade publications which brought back only minimal results, so I have created these personal golden rules which you might like to add to your own illustrator's handbook. (1) Never place an advert if you don't have the money in the bank to pay the bill, and (2) no matter how often the rep tells you that you can place the ad now and pay later, remember that you'll still have to pay for it someday, and, unlike the old riddle, someday *will* arrive.

Paranoia aside, however, successful trade press advertising will ensue if you go through the same steps as we did when we talked about directories. Is the paper or magazine in evidence in your clients' offices. Is it open and being read or is it still in its envelope in a stack somewhere? Worse still, is it on the coffee table in reception? This latter is the worst case scenario. If it's out here *nobody* in the office ever looks at it. Clients never put anything they value on the public side of their offices. Be warned!

The next step in your evaluation process is to read through the last six issues of the publication and analyse the active readership by the adverts. A magazine with an active readership will have a flow of advertising from

Exercise

When I cover advertising at seminars we always end the section with this little fun exercise called *Who's Answering Your Phone*. Let's play it now. You've placed an ad and the chairman of ICI is on the line, now, to offer you a five million pound job.

Hurry, the phone's ringing now. So, who's answering *your* phone? Is it your three-year-old daughter? Your deaf old granny? Is *anyone* at home? Do you have an answerphone? There are thousands of small one-man-bands in the UK who never consider this. When the business-owner is out on a job calls either go unanswered or are answered by children or other members of the family who have no notion of how to deal with an enquiry.

Please don't join these ranks. Either buy a mobile or answerphone to take care of your calls while you're away from your base or train a competent *and willing* member of your family to act as secretary.

Do it now.

the same, often major league, clients. If it doesn't the adverts will be erratic and inconsistent. There will be lots of idiosyncratic adverting, and odd splashes from companies that you've never heard of. Watch out also for out-of-date advertising. If a publication is in trouble it will often fill unsold space with adverts from previous issues to give an illusion of prosperity. Remember that magazines exist to sell advertising space and some will go to any length to maintain those sales. They all want you to think that their publications are hot. Some might not be!

The third step is to analyse the editorial content of the publication. Think about the people who assign work to you. Would they be interested in the articles in this magazine? Does the journalistic slant reflect their point of view? If the answer to these questions is no, then don't pay to advertise in this publication. It doesn't talk to your clients.

And, lastly, *ask*. Ask your clients what their reading preference are. Do they prefer *Design Week* to *Creative Review*? Ring up other illustrators who are already advertising and ask them what sort of response they are getting. [My approach is "Hi, you don't know me, I'm an illustrator like you but my style's *totally* different from yours. I was just wondering what sort of response you were getting from *Bodger's Weekly.....*"] If there are no illustrators in the classified columns already does this mean you have an untapped market or a place that doesn't yield results. Ask the sales reps for back issues and find out for yourself. In fact, make the sales reps back up all the information you require with hard evidence. Don't be fobbed off with meaningless readership rather than circulation figures, AB ratings or any of the other mumbojumbo in the rep's arsenal. Make them state facts and name names. Then decide.

"Tell me, how did you love my picture?"

Samuel Goldwyn

Addendum Learning to Cope With Cold Calling

No, I haven't taken a retrogressive step. If you do decide to place an advert your phone will suddenly become very busy. Unfortunately, it won't always be clients on the other end of the line. All advertising sales reps generate leads by going through their competitors publications and ringing up the advertisers. So be ready for the call. The rep will have (a) been stunned by your advert, (b) have an offer to let you run the same advert with her at a "special rate", and (c) offer to lift your existing copy into her publication at no extra charge to meet her very pressing deadline. **Say no**.

93

The golden rule when dealing with ad sales cold calls is *never* to buy an advertisement on impulse. Only place a paid-for advert once you've been through all the steps outlined above and never, ever, pay for advertising in a publication that you've never seen before, no matter what sexual favours the rep promises you over the phone.

"Barabbas was a publisher."

Kenneth Tynan

6

Free and Almost Free Publicity

"There [is] no need, ever, to pay for advertising"
Anita Roddick

Max's Motto
If You Don't Have To Pay For It - Don't Pay For It

Now if the last few pages have seemed a bit depressing, worry not. The tables are about to be turned. Don't worry if you don't have a "publicity budget" or don't want to have to deal with shyster salesmen. The best publicity is the kind that comes for free and we're going to start by milking freebies from our old friend, the trade press. (And, while we're at it, let's not forget the business pages of our local newspaper.) Now, you're probably wondering just what I'm rabbiting on about, so let me tell you, without any further preamble, that the most powerful weapon in the illustrator's free publicity arsenal is the **Press Release**.

Press Releases

So, what is a Press Release? News. And what do all trade and business pages need in order to keep their publications alive? You guessed it, News. Ergo, if you can supply a specialist publication with free news, they in turn will supply you with free publicity. It's an equation that is quite riveting in its simplicity and, with a little care, using Press Releases will keep you

"Television is for appearing on, not looking at."

Noel Coward

supplied with all the free publicity you need until the day you retire.

Therefore, a Press Release is news about you. So all you need to do is get a sheet of paper, write it up and send it to the appropriate media. But how do you translate what you do on a daily basis into "News" with a capital N, you ask? Easy. Just apply these two simple rules. (1) Make it interesting, ie, something that someone would actually *want* to read, and (2) write your copy up so that it actually sounds like a news story. Let me demonstrate:

I once read a fantastic book called *How to Write for Profit and PR* by a hack journalist called Ron Smith who had, amongst other things, been the Press Officer for the London Antiques Fair. Part of the job spec was to create and generate press coverage for what was, really, a fairly major annual event. Previous incumbents had circulated all the details of the fair to the papers each year and had received moderate coverage in the *Evening Standard* and other London locals. Ron Smith, however, instead of following in his predecessors' footsteps, had gone out and met the dealers who were attending the fair, browsed around their stock and generally poked his nose in and asked questions. This was where inspiration struck. One of the dealers was going to be selling a "haunted chair" and Smith used this as the hub of all his Press Releases using screaming headlines like "HAUNTED CHAIR AT LONDON ANTIQUES FAIR!"

As you can guess, the campaign caught the imagination of journalists everywhere. *The Standard* gave the chair (and the fair with it, of course) a centre page splash, the story made column inches in all the national dailies and even a spot on teatime TV. And, best of all, the fair had its highest attendance for years and all for the cost of some paper and a few stamps. Now that's what I call free publicity.

Hot Tip - Know Your Journalist!

This is the same procedure as mailing clients. Press Releases sent to "The Editor" or headed "Dear Sir or Madam" will not knock anyone over with their brilliance. On the other hand, a Press Release sent to John Smith, Business Editor will land on the right recipient's desk first time.

Study the publications that you're targeting and note all the journalists' and editors' by-lines and match them with the phone and fax numbers you'll find in the magazine's masthead [ie, the bit at the front where they list all the credits and disclaimers] and add them to your Publicity Database.

Even better, find out the name of the Business Editor of your local paper and ring him up, or, better still, offer to buy him a drink. Business Editors are morose and lonely men who are desperate for something that sounds vaguely like real news. Give them what they need, like great stories and, better still, photo ops that don't involve fat men in bad suits shaking hands! Be known as someone with strong opinions, be quotable and always be available for comment and you will be your Business Editor's darling!

Now, obviously, we don't all have haunted chairs to publicise ourselves, but, remember, Ron Smith didn't *know* he had one when he started his Press Release, he just sifted through the material he had available and came up with a small golden nugget which he exploited with great success. You can do that too. Sieve through your own activities, apply a little creativity and mould it into something inflammatory. Here's a Press Release I made earlier, for example.

When I launched my website I wanted to have as much publicity as I could get but didn't think that a Press Release headed "Scratchmann Has Website" would grab many headlines. Now this is going to sound really silly, but in order to get some fresh angles on the project I interviewed myself. [You might be more fortunate and have a friend who'll do the interview for you and save your from mild schizophrenia.] I recorded the 'interview' and then played it back listening for suitable quote material. Out of six or seven minutes of talking to myself I found the line "response has been great so far, in fact, if it carries on I'll have to sell my shoes and just stay at home by the phone!".

OK, OK, it's a cheesy line, but it struck a chord and I used it as my Haunted Chair. Playing on the shoe-selling theme, I produced a Press Release which started with huge type screaming "ILLUSTRATOR FORCED TO SELL SHOES" The heading was followed up with copy saying that I'd opened the site, what was on it and concluding with the shoe-selling sound-bite and, of course, the site address in nice bold letters. It wasn't *Gone With the Wind* but it had the desired effect.

I sent out ten of these missives, six to business & creative magazines, one to the *Manchester Evening News* and the remaining three to assorted geek mags. The result? I received six mentions including a little mini-feature in

Hot Tip!

A great way to get free publicity in a publication is to send them free to use pictures and offer something free or cheap to their readers.

For example, I sent a profile of myself to several musicians papers as a press release, and told them that I'd do a CD sleeve for any of their readers for a (low) fixed fee. I also enclosed a CD-ROM of several high resolution images which showed how fantastic my work was.

100

One of the papers ran the story and I received several commissions, one of which became a regular partnership.

the *MEN* and generated a lot of interest in my site for the cost of some paper and a few stamps and envelopes.

So, what's unusual and newsworthy about what you've been doing lately. Have you worked on an unusual campaign? Are you engaged in something that benefits the community? Have you won an award? Have you had a major order from abroad that shows the superiority of British illustration over filthy foreign competitors? [Journalists always go for this one!] Is it interesting? Is it news? Can you present it in such a way that it will be? Interview yourself or get a friend to do it for you. Play the tape back over and over. Break it up into 'soundbites' and look for angles that you can hang a story on. Turn the mundane into a story by concentrating on unusual angles. "Freelance illustrator does poster for local firm" is pretty boring. "Local jobs saved by inspired poster campaign by freelance illustrator Joe Bloggs" makes a fantastic story out of the same event.

How to Write A Press Release
That Produces Results

1) When constructing a Press Release structure it like an advert. (Study adverts in magazines to see how it's done, or, if you're not good with words and have a couple of bob to throw about, hire a freelance copywriter to do it for you.) Start with a snappy attention-grabbing opening line (called a hook in copywriters' jargon) to catch your readers' interest, then put your body copy into short, easy to follow paragraphs. (When I had a one-man-show in a London wine bar I used the hook **"Illustrator to be HUNG in Soho bar!"**) If you have a lot of information to put across divide it up into easy to digest soundbites or boxes like the *Hot Tips* in this book, or, should you have lots of facts and figures or tables, put them on a second backup sheet.

102

"Everything you read in the newspapers is absolutely true, except for that rare story of which you happen to have first-hand knowledge, which is absolutely false."

Erwin Knoll

2) Always end your Press Release with your contact phone number and fax & email address.

3) Always turn your copy into a story. Make it interesting and readable. Remember, journalists are a fairly lazy breed. If you send them a well constructed snappy piece that can run as it stands without massive rewrites then you've backed a winner. In my own experience of working on a newspaper, there tends to be a blind panic come deadline day to fill any gaps left between the adverts and the major stories. Design your Press Release to fill those spaces.

4) If humanly possible, enclose a CD with free-to-reproduce high resolution images with your Press Release, they're worth a thousand words!

5) Lastly, always remember that you are unique and that nothing you do is too small to make into a Press Release. When I get a commission that's even slightly out of the ordinary I send out a Press Release. When I lived in Manchester I received a commission, via the internet, to design some T-shirts for a firm in Tokyo. I turned this into fashion news - *Manchester Illustrator Designs for Top Tokyo Fashion House* - and internet news - *Max Receives Top Japanese Job via Net* - and generated a lot of publicity for a couple of pounds.

6) Use your Press Release to get your name mentioned in all forms of media. Newspapers, magazines and even radio and TV. Never be afraid to send your Release to the highest peaks of the media, after all, if they don't use it what have you lost? A stamp! Likewise, make full use of all the small hillocks. Web magazines, community newsletters and even in-house journals. In fact, mentions in in-house journals are a great source of free

A Networking Story

When the notoriously illustrator-unfriendly Penguin Books brought out Red Dwarf's Craig Charles' copiously illustrated book of poetry, **No Other Blue**, the illustrations were by the then unknown artist Philippa Drakeford.

So how did not long out of art-school Philippa land this plum assignment from a publisher who maintains a virtual fortress to keep illustrators out?

Networking.

Being a Red Dwarf fan, part of her personal work consisted of a portrait of Craig, and when she went to see her idol in his stand-up show she took it along knowing that he signed merchandise for fans after the show. On seeing the portrait amidst what must have been a huge sea of faces he took the time to mutter "That's good, that!" and Philippa, being the natural networker that she is, went home and drew another portrait and sent it to him.

There was no acknowledgement and she heard nothing for well over six months and then one day the phone rang. "Craig's doing a book. Would you like to illustrate it?"

Never under estimate the power of networking!

publicity for freelances. If you're currently in a studio job that you're about to leave to set up as a freelance make sure that you get a farewell splash in you old firm's journal, saying what you've done and what you're setting out to do and ending with your phone number! It may seem like a somewhat futile gesture, particularly if the company is chucking you out, but the **networking** possibilities from such exposure are endless. And what do I mean by networking? Read on...........

Networking

Networking is another great free way of generating publicity and work opportunities for yourself, and its beauty lies in its pure simplicity. Basically, it works like a Chinese Whisper. Simply decide on what you want circulated and then *tell* everyone that you know about it. The idea behind this is that if you tell people that you are setting up as, say, a freelance medical illustrator, that some day in the yet to be future they will bump into someone who says "I need someone to do some medical illustration work for me" and they say, "Oh, I know a bloke" and a contact is made.

Now, this might sound a bit far fetched, but I can assure you that networking *does* work. It's not instant but it is effective, and, like anything else, the results that you can achieve are commensurate with the work you put in. I use networking quite a lot, being a gregarious person who tends to talk a lot, but I pale into insignificance alongside experts in the field like my friends, editor Sinclair Newton and trainer Penny Vingoe, who are both masters of the networking art, so let me tell you a little about how they 'work a room'. Both have big ears and long noses - metaphorically speaking, of course! - they listen to everything and talk to everyone. When either enters a room filled full of people they go into action. They listen,

Hot Tip! - Going Digital

If you've never heard of Cow Gum you probably don't need to read this section. If, however, you've just experienced a wave of nostalgia for that old graphic designer's legal high in it's familiar red & white tin you'd better read on.

Illustrators my age and older have fond memories of a cosy industry where clients gave you tea and biscuits and illustration involved pots of paint and bottles of ink and racing to the post office to meet deadlines, and while this glowing picture of how it used to be is never going to come around again, there's no need for old illustrators to be like old dogs - we are all perfectly capable of learning new tricks.

If you're a textural type of illustrator you'll probably find the transition to the matt-black and gun-metal world of the Mac a hard one, but that doesn't mean that it can't be an enjoyable one! Remember, your Mac is there to augment what you can already do with ink and brush. It is not there to replace your old tools but to enhance them.

Go into computer art gradually if you find it intimidating. My first 'digital' piece was a standard hand-done composition which I then scanned into the Mac and sent to the client via FTP rather than post. Remember, it's *your* art, create it in the way that suits you best. You don't have to throw away all your pencils and pens in favour of Adobe Illustrator if you don't want to. Many comic artists, for example, still do all their art by hand up to the inking stage, then scan the finished piece into the computer and colour in Photoshop.

106

Continued on page 108

they ask questions, they pry, they inform, they pass over and collect business cards. I always say it only takes them five minutes to learn a whole room's history and have recruited half a dozen friends for life.

Think of networking as planting seeds. If it doesn't sound too much like Miss Prism, the more you sow the more you reap. If you tell ten of your friends about your new illustration career they may tell another five people each, so that's sixty people who know all about you, and if, say, those people tell another three people each that's another hundred and fifty you've added to your list of potential customers. And what if *they* all tell a couple of people each?

Now think about the coverage you could achieve if, instead of just telling ten of your friends about what you're doing, you go out and tell a hundred people, and they in turn tell ten people each. The numbers begin to get quite frightening, and then think, what if you told a *thousand* people about yourself and they all told another ten people. The possibilities are endless.

So don't be shy. Talk to all your friends and colleagues, your family, your neighbours and your neighbours' neighbours. Tell other business people you meet at training groups, or people you meet at professional associations or chamber of commerce functions. Tell your bank manager and the girl on the bank till. Tell the guy at the supermarket and the woman who fixes your car. *Always* tell your hairdresser (in fact, I've been told stories of people who wanted an 'in' in certain companies actually finding out who their targets' hairdressers were and becoming clients just because they knew how good hairdressers are at passing along information!) and don't forget about the tradesmen who come to fix a fuse or service the washing machine. Tell them all.

Continued from page 106

The thing that you *mustn't* do is panic. I met a lady a while ago who had stopped working in the eighties to have and bring up her children. When she thought about coming back to work almost twenty years later she was horrified to find that she felt like a stranger in a foreign land. To top it all her husband went out and bought her a trendy new i-Mac which she couldn't get a handle on at all, so went out to a class full of nineteen-year-olds who all whizzed ahead of her and just made her feel ten times worse.

108

The last I heard of her the i-Mac was back in its box and she was looking forward to baby-sitting her as yet unborn grandchildren.

So, treat your Mac with caution if you're not used to it, and go into the digital world one "baby step" at a time. Play with the software. Learn that a Photoshop filter does not a piece of art make and, above all, have fun!

Oh, and don't fall into the other oldsters trap of learning just what you need to know in a programme and ignoring the rest. Your Mac can help you to create wondrous things. Keep on pushing it!

Get into the habit of always carrying your business card and hand it out to people. In fact, when you meet other business people give them your card and ask for theirs as a matter of course. This allows you to build up a little database of people you can ring up at some later date and say "I don't suppose you remember me, but......." In fact, just network all the time. It costs nothing and the results can be quite staggering.

Maybe you could even utilise a free advertising space for a bit of networking? The backs of all your envelopes? The rear windscreen of your car? The back wall of your shed? Think about it!

Direct Mail

Many years ago the Halifax toffee manufacturer John Mackintosh (as in *Quality Street, Toffo, Toffee Crisp* etc) gave a speech to the advertising world that riveted the entire industry with its astounding simplicity. Mackintosh, who knew all about the value of advertising and publicity, astounded everyone by announcing that he considered an advert for his toffee in the **Daily Mail** was a great investment because he could use it to reach millions of people for a fraction of the time and cost it would take him to write to them all individually, even if he knew their addresses, which, of course, he didn't.

The ad men bowed down and worshiped and the **Mail** itself reprinted the speech and sent it out to all their advertisers. Everyone was stunned by the incisiveness of Mackintosh's logic and his hypothesis holds true to this day. Or does it?

If you're selling something with the universal appeal of, say, toffee or chewing gum or cars, then, yes, blanket coverage in a national daily or

110

"Dear *Readers' Digest*, we hardly know each other, yet I have been selected from so many millions to enter your free contest in which I may win £25,000. You have made me very happy."

Miles Kington

primetime TV is probably still your best bet, but where does that leave us? We don't sell toffee. In fact, we don't sell goods at all, we sell a service, and, rather than targeting the general public, we tend to sell our services to certain key individuals in our chosen fields, so, even if they do read the *Daily Mail* along with several million others, it might be a slightly expensive way to get in touch with them.

So how do we reach our target audience without breaking the bank? We've done our networking, we've sent out Press Releases. Now we're out to get our birds in person with some really serious publicity and the medium we're going to use is Direct Mail.

Now most us associate Direct Mail with the junk mail that pours through our letter-boxes or the Spam that clogs up our email boxes. It's pure junk, we say, no-one ever reads it, yet big companies like *Readers Digest* and *Which?* use it all the time I've even had junk email signed by Bill Gates and Roy Disney Jr. So, what's the story here, are these companies pouring their money down the toilet or does Direct Mail really work? Believe it or not it's the latter, Direct Mail works. In fact, used with a bit of intelligence, it is one of the most efficient and cost-effective methods of publicity we can muster up and, once you learn its quirky little ways, it will generate high results for very low costs.

Traditionally, Direct Mail has yielded about a one per cent success rate or, put another way, you could expect one sale for every hundred letters you send out. However, with more and more sophisticated customer profiling technology appearing each year and the emergence of more and more data on the market, the response rate for Direct Mail is shooting up every year and, of course, we self-reliant illustrators can achieve rates like fifty or sixty per cent responses to our keenly targeted mailings.

112

"Don't tell my mother I work in an advertising agency. She thinks I play the piano in a whorehouse."

Jacques Seguela

So let's get started. Before we actually write our first Direct Mail shot let's pause for just a moment to consider the two main advantages to using Direct Mail as a publicity medium. Firstly, with Direct Mail there is no restriction on the space you can have to sell yourself. In traditional media you're always having to budget in half pages or column centimetres, with a mail shot the world's your oyster and it doesn't cost much more to print two or even three pages than it does to print a single one, plus you've got a monopoly on your prospect's attention and your material isn't rubbing shoulders with your competitors like it would be in, say, the classified advertising section of your local newspaper.

Secondly, Direct Mail allows you to be very specific about just who you're writing to. You can target people in a certain industry, in a certain town or even in a certain street. I received a hand-delivered mailing from my local cafe the other day offering me free coffee every time I eat my lunch there. My video library sends me mailers when it gets in new titles in the genres of film that my records indicate that I like to hire. I split my own database into industries like theatre, advertising, magazines, book publishers and use this to create personalised mailings which generate responses. It works both for me and on me. I respond to Direct Mail and so do you. Sure, we all throw away the "You Have Won A Million" *Readers Digest* promotions, or say we do, but think back over the last year. Have you bought something or gone into the supermarket with a money-off voucher that came through the mail? I'm willing to bet money that you have!

I have found the work-generating potential of Direct Mail to be limitless and I have a rather overzealous ad-salesman to thank for opening my eyes to its possibilities. It was a couple of years ago and I'd been reviewing my client database and discovered that I was being grossly underused by the

A Word on Mailing Lists

The reason that many people have used newspaper advertising in the past is because, like John Mackintosh, they simply didn't know the addresses of the people they wanted to reach. Well, them days are gone for ever. As we've already discussed, you will have or be busy building your own personal database of contacts, then there are all the published trade directories plus the many, many sources where you can now buy mailing lists in any demographic or geographic category you desire.

These latter usually come printed on sticky labels so that you can save time by putting them straight onto your envelopes, however, you may prefer to rewrite these - a hand written or typed envelope looks much better at the other end than a stuck on label which cries out "Mailing List!".

greeting card industry. I decided to remedy this by placing a quarterpage ad in the main trade publication for the industry and rang up for a rate card. This duly arrived and I promptly fell over, not only at the price but also at the slant of the magazine, and decided put the project on hold. However, fate intervened in the form of an ad rep, who was soon on the phone trying to change my mind.

HIM: Why aren't you going to advertise?

ME: Because the rate is too high

HIM: But you'll be reaching over three thousand readers

ME: Yes, but most of them are Greeting Card Retailers and no use to me. I want to get to publishers and commissioning editors

HIM: Ah, but they read the magazine too!

ME: Yes, but there's less than a hundred of them. I'd be cheaper just writing to them with samples, wouldn't I?

LONG PAUSE

HIM: Yes, I suppose you would.

I was astounded. I had had the solution in my hands all this time and had never stumbled on it. It was John Mackintosh's theory in reverse I knew where to find the people I wanted to reach and it was actually cheaper and faster to write them a letter rather than reach them with an impersonal advert. My first mail shot was born.

I drafted up a to-the-point letter to accompany some sample cards that I had made up and, as I was initially contacting only thirty people, used the mail merge facility on my Mac to address everyone I'd written to by name. I received nine responses from that mailing, which is about thirty per cent, and was more than sold on the magic of Direct Mail.

Hot Tip!

As an illustrator you probably won't be mailing more than three hundred people at any one time, so take advantage of these low numbers and *always* hand-sign your mailing letters for that personal touch.

So stop and think. Who do you need to get to with your publicity. Do they number in tens, hundreds or thousands? Do you know where to find them? If not, could you get a directory or mailing list of their addresses? Now get out your chalk and slate and do some sums. What's the cost of a good size ad in *Creative Review*? Compare that to the total cost of stamps, envelopes and print / copying to write to everyone you want to reach instead. If the former is more expensive then go for Direct Mail.

What Do I Put In My Mail Shot?

I'm going to be irritating here and answer your question with a question. What do you want it to achieve? Creating a Direct Mail Shot is like setting out to achieve your dreams. You need a goal. So, what is the purpose of the mailing? Do you want to make clients aware that you exist? Do you want work? Are you drawing your clients' attention to some other form of advertising such as a website? Are you giving them advance notification that you will exhibiting at a trade fair? The list is endless. Therefore you must decide (a) what it is that you want to tell your clients and (b) how many of them you want to tell. Then do your sums. Assuming that Direct Mail is the most cost-effective medium it's time to decide on the format you're going to use. There are three to choose from:

The Letter

If you have something very specific to say you can't beat using a letter, and if you have a mailmerge software on your Mac it's even better. What client could resist your pitch when it starts "Dear Mr Jones......."?

Opinion divides amongst direct-mailers on the preferred style of mail shot letters. Some people opt for the deliberate 'copy' letter where no attempt is

I. L. Fixit
41 King Eric Court, Manchester M13 0FU
0161 222 1234

Fred Bloggs
Art Director
Bodger, Banks & Bloggs plc
Fashion House
Manchester M60 5FU

Dear Fred,

<u>Can You Afford to Pay Staff to Sit Around Doing Nothing?</u>

These days, when turnover fluctuates more than the temperature does, it's difficult to know just how much talent to employ. You don't want to lose valuable orders, but you don't want to allocate wages to creatives who won't always have enough to do either.

As a freelance fashion illustrator I think I can help you out. I have fifteen years experience of the clothing industry and am available to step in at a moment's notice any time your regular staff get swamped.

Why not give me a call on 0161 222 1234 for an informal chat?

Best Wishes

I. L. Fixit

Ian Fixit
enc
PS: A list of clients I've worked for since we last met is enclosed

made to conceal the fact that this a Direct Mail Shot which has gone out to hundreds of people, while others prefer the more 'friendly' approach where the mailer is designed to like a piece of personal correspondence between the mailer and the recipient. Both methods have their plus points and it tends to be a horses for courses situation. The copy letter, on the one hand, is effective because it's punchy and to the point. If you're good with words (or have the budget to bring in a freelance copywriter) you can create some stunning copy letters. I received a great one from someone selling an investment magazine the other day. It ran for four pages and was so engrossing that I read it right through without putting it down!

The Copy Letter

This letter incorporates three essential points which you should always try to include when you're creating a copy letter:

a An interest-grabbing heading, preferably in the form of a question. "Can You Afford to Pay Creative Staff to Sit Around Doing Nothing?" "Could You Employ Somcone to Do This Job for £100 a Year?"

b A brief statement outlining what you perceive to be the client's problem. "Are you over staffed?" "It's so hard to have top notch people on hand when you need them" etc.

c Most important, your solution. "I'm freelance, I'll work when you need me" or "I'm cheaper than full time staff" or "I don't expect you to pay me when I'm not needed" etc.

I know I mentioned a stunning four-page-long direct mail letter, but, unless you're sure that you can compose attention-grabbing copy with the "pt" of

Ann Illustrator

14 Beckhamanposh Court, Manchester M13 0FU
0161 222 3344

Fred Bloggs
Art Director
Bodger, Banks & Bloggs plc
Fashion House
Manchester M60 5FU

Dear Fred,

 Just a line to let you know that I've just been awarded the **Golden Pencil Sharpener Illustration Prize** for my catalogue illustrations for Wear & Tear plc.

 As Wear & Tear attract much the same customer base as yourselves I thought you might like to look through the enclosed copy of the work I did for them. It should strike a few chords and I have lots of ideas which could be profitably employed in your own excellent catalogue.

 Why not give me a call on 0161 222 3344 for an informal chat?

 Best Wishes,

Ann Illustrator

Ann Illustrator
enc

a Stephen King novel I would recommend that you add my little rule about copy letters to your personal maxims.

If it won't fit onto a single page it's too long

Now this doesn't mean that you can't enclose additional sheets with your letter giving CVs, client lists, pictures, etc, but please try to keep your main selling letter to one easy-to-read A4 sheet. Clients have small brains - don't over tax them!

The Personal Letter

This letter again makes use of the same three points in a more subtle way. The brash hook-style heading is gone but the opening paragraph still does the same job. Again, we make a more subtle reference to the client's perceived problem, this letter merely *infers* that Wear & Tear (ie, the client's competitors) are doing better stuff, and, finally, again offers the client the freelance's solution, "Mr Client, you too can use an award-winning illustrator for your catalogue".

At the end of the day, the personal letter will do much the same job as its brasher cousin. Its advantage is, of course, that it's more user-friendly than a copy letter, but it does lack the punchy selling skills of the former. Quite frankly, the type of letter you decide on really boils down to what feels right to you at the time, and you might find, as I do, that there's room for both approaches according to the subject matter in hand. The choice is yours.

The Advert

Some people don't like messing around with letters and prefer to be more

Hot Tip!

Although your phone number will always appear on your letter heading *always* repeat it in the text to add emphasis when you invite your client to contact you.

straightforward when mailing their clients. If this is you then you'll want to know how to make best use of a simple advert. Adverts don't bother with the personal approach, they go straight for the jugular. Using a direct mail advert is just the same as placing an advert in a directory or newspaper except *you* decide who it goes to and, therefore, don't pay for reaching people you're not interested in pitching to.

I find that an advert mailing works best if you have something very specific to say. If, for example, you just send out adverts which say *John Jones Freelance Illustrator* you won't get as good a response as you would if you said:-

Does Your Copy Need Brightening Up?
Let My Illustrations Bring It to Life!

John Jones Freelance Illustrator
0161 222 3333

I used an advert form of mailing with great success, for example, when I mailed selected clients in the greetings card industry. I created [what I thought was] a really humorous card and had it printed up with the message "to commission cards like this please contact Max Scratchmann" inside.

Adverts are also exceptionally good at publicising other promotional mediums or events like web sites, trade fairs or even TV appearances. An illustrator with a new website, for example, could try:

Need an Image?

Hot Tip! - A Word About CD-Roms

One of the best ways to send lots of artwork quickly and cheaply to a client is to put your whole portfolio onto a CD-Rom.

Software like Photoshop will create a great virtual portfolio for you or you can use Powepoint, Flash, Director or simple HTML coding to create a great browser or slideshow presentation, and, for a few pennies, you can send your client literally hundreds of pieces of art.

Before you rush off to burn hundreds of discs, however, there are a couple of things that need to be taken into consideration. If you send a postcard to a client he sees your image as soon as it lands on his desk, he doesn't even need to open an envelope. You are wowing him with the brilliance of your work without asking him to do anything.

When you send a CD through the post, however, the client has to (a) open the envelope and (b) put the disc into his computer's drive, so he needs to be given a good incentive to do this. (He'd rather eat a biscuit!) If you do send a CD make sure it's in a picture sleeve which will work in the same way as a postcard with an eye-popping image, and, of course, your contact details. The disc itself should also have an image printed on it as well as those all-important contact details and your email address should always appear as a clickable link every time it appears in the actual disc contents.

You can, of course, have business card sized picture CDs produced which, in theory, are a fantastic idea as they combine a wallet-sized card with a CD but bear in mind that many Macs have auto-feed CD drives and won't play them!

Visit Algernon Jones' Website

on

www.greatpix.com

to view the exceptional work of this talented young
digital illustrator

Simple copy like this, with a suitably striking image to make the point, will create a very successful advert mailer.

Likewise, a freelance illustrator attending a trade fair would do well with a mailer like:

Meet Freelance Illustrator

Christine Chorley

at the International Art Trade Fair,
Town Hall,
Bolton
4th to 6th July

All you need is some of Christine's art plus a map of the fair layout with her stand well highlighted and you have another great advert ready to mail. You get the general idea.

Used intelligently adverts can be an effective - and cheap - use of direct mail. In my opinion, their only downside is that when you're trying to ask

Hot Tip!

No matter how large or small your mailing is, there's nothing more fiddly than sticking stamps onto envelopes. Franking machines are probably beyond the scope of most of us illustrators but you can get around the problem and save time and mess by buying self-adhesive stamps or ready stamped envelopes which Royal Mail will supply you in boxes of a hundred.

If you hate post office queues you can buy postage stamps on line and there's also a subscription service available called **Smart Stamp** that prints onto an envelope or sticker via your Mac's printer and you pay for the postage 'credit' by account.

See **www.royalmail.com** for details.

for work in a general way they can be a bit too forceful. For example, you can say "I know you're understaffed, why not use me?" in a letter and it sounds helpful and considerate - put this into an advert screaming *You Need Me Mate!* and it becomes aggressive and challenging, and, subsequently, easier for the client to chuck into the bin. Of course, there's no reason why you can't *combine* the two forms and pair up a heavyweight in-your-face advertising leaflet with a softer-sell personal letter and get the best of both worlds. Remember, there are no laws in publicity, you can do whatever works best for you.

The Newsletter

The third type of Direct Mailer is the Newsletter, which can be a very powerful tool in the right hands, but, in practice, tends to be one of the most underused forms of publicity in the mail. The typical corporate newsletter usually consists of boring copy, graphs, charts and pictures of fat men in suits either shaking hands, grinning at computer terminals or slouching behind desks with phones protruding from their ears. Bor-ring! (Well, would *you* bother to read it?) What's more incredible is that most of these come from specialist media companies who charge businesses an arm and a leg to run up these glossy yawn-makers.

Now, the waste of trees not withstanding, this is a shame because newsletters are really great publicity-grabbers and, as illustrators, something that we should all cultivate and utilise to the full. Not only are they a cheap and effective way of keeping in touch and drumming up business, with a little imagination they can also be something that clients actually look forward to receiving.

So, what makes a great newsletter? As usual, it depends on who you want

Hot Tip!

Your newsletter is your free gift to your client. Always include a box or page on your website where clients can sign-up for it. (You can get simple one-click subscription software from **www.mailchimp.com** which can easilly be incorporated into your website's pages.)

Likewise, provide a form in your paper newsletter or link in your email version where they can subscribe or give you a colleague's name and details.

Remember, if we don't ask we don't get!

to read it, and, as we discussed earlier, a newsletter also needs its own personal goals and objectives. So, firstly, who do you want to read your newsletter? Does the content appeal to that person. Visualise an actual client. Would Fred Bloggs of Bloggs & Co take the time to read your newsletter? Would he enjoy it? (Remember when we were talking about assessing trade papers to see if their editorial content spoke to our clients? Use the same tests here.) Secondly, ask yourself what you want to achieve by your client reading your newsletter. Do you want to generate work? Create awareness? Keep in touch? Once again, is the content of your newsletter achieving these objectives? **Decide what you want your newsletter to do and then plan your content accordingly.**

Remember, it's *your* newsletter and what goes in it is entirely up to you. There is only one golden rule to stick to - YOUR NEWSLETTER SHOULD **NEVER** BE BORING! Keep it lively, funny if possible, and keep it interesting. Your newsletter should be an extension of your own persona. I'm a rather garrulous quirky sort of person so my newsletter has lots of little boxes with funny quotes, jokes etc. You might be a more serious person than me and prefer to include organic food tips or little known facts about the rain forest or whatever. You're the boss, you know the image you want to project, so you know what you'll put in your own newsletter.

I spend a lot of time thinking about my clients when I'm planning a newsletter. I would describe the majority of the designers and art directors who commission me as rather eccentric cultists with short attention spans so I divide everything neatly into easy-to-digest soundbites and keep an overall cultist feel to the whole publication. I know, for instance, that they're not interested in my turnover for the last year so I don't tell them about that or give them graphs to show how well I'm doing. A typical

Hot Tip!

As well as your regular mailing list, it's also well worth sending your newsletters to your local paper's Business Editor and all relevant trade journals. It helps to keep you in the forefront of their minds, plus, if they see something that catches their interest they'll make it into a little feature and generate some more free publicity for you.

newsletter from me is sent both by post and by e-mail. The paper version usually consists of a single-sided A4 sheet on pale coloured paper. This has the double benefit of being easy-to-read *and* cheap to print. The content usually divides into:

1 **Hard News Story**, such as winning an award, being commissioned by royalty etc

1 **Feature Story** like a very eccentric commission or an anecdote or funny story

1 **Competition** where I offer something like a free T-shirt [plugging me, of course!] for the best joke faxed in on a given theme or whatever

2 or 3 **Fillers** which are jokes, quotes, bits of topical humour etc, and, lastly

1 **Special Offer** whereby I quote a special rate like, say, any book cover designed for only £200 until the end of the month.

Now if that doesn't sound like a good mix to you don't worry. Just because it happens to be *my* mix doesn't mean that it'll be suitable for everyone. The only thing that I think you should *always* try to include in your newsletter is a Special Offer simply because they work so well. There's nothing better for getting the client onto the phone than offering him a good deal, and if you make the offer finite, that is, put a closing date on it and thereby motivate him to pick up the phone and ring you today rather than tomorrow, then you have a cash-generating formula. I've found that, on average, I get between one to three jobs per newsletter as a result of Special Offers, and, recently, I've been increasing this response by splitting my mailing list into broad groups and altering the newsletter so that each group receives a special offer that is pertinent to themselves. This way book publishers are now offered a great deal on a book cover, theatre producers get money off a poster, and record companies can have a really great album cover at a competitive price.

How to Create a Newsletter that Your Clients Will Actually Read

1) Set objectives - who's going to be reading your newsletter? What do you want it to achieve?

2) Create a feel or persona for your newsletter, if you're quirky and humorous then that's what your newsletter should be.

3) Don't be too ambitious. Keep your newsletter compact. I go with a single-sided sheet of coloured A4 paper which I have run up at my local copy shop. Quick to read and cheap to print.

4) Keep your editorial content easy to read. Be chatty. Include humour and gossip.

5) Always ask for feedback. I always invite my clients to faxback to me with their comments and I always have a faxback competition for them to enter. You could also include a faxback survey sheet with a prize draw if you don't fancy a conventional competition.

Using a Mac for the original of your newsletter makes something like this very simple; for example, I just produce three originals to take down to the copy shop instead of one, but it's just as easy to print all the copies yourself if you have a sturdy enough laser printer and you can even use a Mail Merge programme to personalise it still further and address your clients by name in the text.

As is probably obvious, I like the newsletter as a form of publicity. One of its best features is that you can use it to "touch base", push your services, drum up business and 'educate' your clients to your way of thinking *all at the same time*. If your newsletter is genuinely quirky and interesting your clients *will* read it and start responding. In fact, you'll know that you're on a winner when they start entering your competitions! All in all, when you consider the publicity & good will you can generate as compared to the cost of some photocopying, stamps and envelopes it becomes crystal clear that you really can't lose.

The Internet

You may love or hate the **Internet** or **World Wide Web** but, like it or not, it's here to stay and again, like it or not, is a major marketing tool for all of us image-makers in the twenty-first century. Whatever its faults - and they are many! - the web is an extremely efficient publicity (and sales) medium for one-man-bands like ourselves and it has the unique ability to put your portfolio where any art director in any country can view it at any time and contact you straight away.

Everyone who has a website has a URL or 'address' such as www.annillustrator.com and you can visit any site you like directly simply

Geek Tip!

Being on the web is easy - being *found* on it is another matter, so it's very important to make your website and your URL as search-engine-friendly as you can.

This includes doing nerdy stuff like the use of meta-tags, keeping Flash to a minimum and using keyword links. If, like me, you haven't a clue about this kind of stuff there are loads of books on the subject and you might want to take a look at **"Search Engine Optimization for Dummies"** or one of the numerous other similar titles on Amazon (www.amazon.co.uk) or in your book shop or library.

Don't *ever* pay out loads of money to firms who ring you up offering to put you in a Google top ten search category! Anything that they can do can be found in a book like the one mentioned above, and for a fraction of the cost.

by keying in the address.

All major firms now have web sites where you can download product information at the click of a mouse rather than having to wait days for a brochure to arrive, and you can even make your purchase on the spot by just filling out the on-screen order form and supplying your credit card details .

This is all lots of fun, of course, but as illustrators the most important development of the world wide web is that more and more decision-makers are using it to search for *services* and if we want our share of this market we need to be out there rubbing shoulders with our competition. I've had a website site for just over nine years at time of writing and, while it's not magic, I get enquiries from clients all over the world plus I've had commissions from as far-a-field as New York and Tokyo.

Yes, Yes, Yes! I Want A Website How Do I Set One Up?

Now you may have heard stories of web sites costing businesses thousands of pounds to design and have already decided that the web is not for you, so you'll be delighted when I tell you that you can have a simple site for well under a fifty pounds a year. The first thing you need to get is a site host who will rent you server space (which is usually sold in megabytes) and register a domain name for you (ie, www.annillustrator.com).

Most site hosts only rent you space and expect you to design your own site and up-load it to them by FTP. You can do this quite easily using simple HTML or Dreamweaver, but, if you're not a geek and don't fancy building a site you're probably better off joining one of the big communal illustrators sites like the AOI's (www.theaoi.com) which provide you with templates to drop your images into, or you can put together a *very* basic

Communal Web Sites

Some people might feel a bit left out in the cold with an independent site in vastness of cyber space and might prefer to find their niche on a more cosy communal site instead. There are hundreds of these for all categories of illustrators and they work by registering the main site on the search engines with a heading something like "Home of Freelance Illustrators".

Once the client has reached the Home Page (a Home Page, for non-geeks, is a bit like the contents page of a book) of a site like this she can then use an internal search engine, which usually allows her to search under name, location or type, to find the illustrator of her choice. The AOI , for example, has a site where illustrators can rent space on a per-image basis and it's up to the individual freelance whether they want to be represented by one or one thousand images.

The plus point of these sites is that they are already established and clients use them to cruise for illustrators that take their fancy rather like kerb-crawling in the red light district but, on the down side, you are cheek by jowl with the competition and run the risk of being eclipsed by flashier or more experienced illustrators. Again, you can combine resources and be on the communal sites *plus* have your own one!

Check out monster sites like **www.theaoi.com**, **www.theispot.com** or **www.portfolios.com** to see if you'd like to be on one of them. Some big sites give you a free image or entry, which is a really good way of testing the water if money is tight.

website in programmes like Microsoft Word or find a site host who will also design a simple site for you plus rent you server space for an all-inclusive fee.

There are hundreds of site hosts around and you can find them in internet magazines or via Google (www.google.com), or, if you prefer, you can go to a firm called Compila (www.compila.com) who host my site for me and who'll give you a very cost effective deal. Your website can be a compact single page with a couple of images on it, or it can be large multipage portfolio of your work - it all depends on how much space you feel you need or can afford. You can use a free 'blog' site like My Space (www.myspace.com) to display your work or even get a 'free' website - go to Google and type in "free website" - but remember that in life there ain't no free lunch and 'free' sites are cursed with intrusive banner, or even worse, pop-up, advertisements plugging the sponsor and detracting from the real purpose of the site - you!

Don't be afraid to have a compact site. Some illustrators have huge gallery-style sites which act like a cyber-portfolio of their work but a single page with two or three illustrations will work just as well to get you started. It's really up to you and your budget how big you want to go - for example, I designed my own site in simple HTML and it runs to a (rather sprawling) couple of hundred pages, whereas my e-mail buddy Henrick Drescher keeps a more compact Flash-driven slide-show site at www.hdrescher.com.

Our objective as illustrators on the web is the creation of a **SELLING PRESENCE** and, contrary to what popular culture might tell you, size *doesn't* matter. Remember, the purpose of your website is to **sell** your art, not to provide a free games room for teenagers! Multi-nationals like Coca-Cola are on the net for different reasons from us. They want to create

How to Create an E-Zine That Gets Results

An e-newsletter has the advantage that it can be sent out quickly and without time consuming addressing, stamping and stuffing of envelopes, but in order to maximise its effectiveness there are a couple of dos and don'ts to add to your book of rules:

Don't include downloads with your newsletter - if you're including illustrations as part of the newsletter don't send them as PDF attachments because most art directors won't bother to download and open them. Host the images on your website and use HTML image tags where you want them to appear (I use a service called Mail Chimp for this - **www.mailchimp.com**) or skip pictures altogether and just put links to them or use a box saying something like "Hit the reply button for fantastic samples by return!" (people who've actually asked for samples will usually take the trouble to open a PDF file!)

Do include links to your website or page in someone else's website, don't simply give the web address and hope that your readers will key in the details themselves. Get real!

Don't make your newsletter over elaborate. There's the risk that people won't be able to read it due to compatibility conflicts and, again, if it takes too long to appear on screen people will hit the next button and not bother to look at it at all!

138

Continued on page 140

'brand awareness' and can afford huge sites with loads of flashy graphics and slick video games for kids to amuse themselves, but not only do sites like these cost a bomb they take *ages* to load ie, it takes several minutes for the site to appear on your prospective client's screen - and the average art director will have lost patience and gone off elsewhere long before *any* of that state-of-the-art graphic design will have appeared on her screen.

So keep *your* site simple and effective. Make it clear what sort of illustration you do with one or two *well-chosen* images on the home page (ie, if you're not a cartoonist don't feature cartoony work on your site - it'll only confuse the old darlings!) and **highlight** that vital contact number and/or email link. Your site host can provide you with statistics of how many people visit your site - or try www.amazingcounters.com to place a visual counter on your site - and make sure that you have registered with all the search engines. There are hundreds of clients out there who don't know you exist - they will just search the net under "illustrators" when they want an image, so make sure that when your client keys in his query his search turns up a link to *your* site.

Email

And, lastly, a few words on email. Email is just post that comes via the internet to your computer's email box rather than through your letter box and *all* the above mentioned publicity mailings work just as well on email as they do in the conventional post. If you have your own Mac you can use email mailing lists to send full colour documents through cyber space for pennies rather than pounds at the click of a mouse. In fact, 'junk' email mailings are already so prolific that they have their own name in geekspeak - Spam.

Continued from page 138

Do supplement your e-mail newsletter with webcards and/or frequent single images (portfolio up-dates) with your phone number and e-mail link.

Don't waste money on CDs that promise things like "57 million e-mail addresses". Hedley Negus of WebWorld adds: "using these will cause you big trouble and these activities are usually only promoted by failed pyramid selling scheme victims and other sad people!"

140

Do use the Blind Carbon Copy button when sending out e-zines and protect the privacy of the people on your list!

You can use email as your sole mailing medium or you can combine it with your conventional stamp and envelope stuff. I've started doing a monthly concise version of my newsletter which I email to my clients as a back up to the black & white hard copy which goes through the post three times a year and I occasionally do an email only mailer if I'm targeting clients in countries outside the UK, or if I want to put something out very quickly.

Like any other medium, email can generate results if used with care, and applying the techniques we've already discussed for snail-mail will produce results for any illustrator who wants to put it to use. Keep your emails lean and mean, provide links to illustrations or use HTML rather than embedding images or using attachments, and above all, write good subject headers that *don't* sound like you're selling Viagra.

142

"The only difference between doctors and lawyers is that lawyers merely rob you, whereas doctors rob you and kill you too"

Anton Chekhov

7

Paperwork

"Where Art and Commerce are long-time companions"
Chip Kidd

Well, that's nearly all the technical stuff over with. You are now almost ready to go out and carve an illustration career for yourself, and, if you're still with me after reading all the preceding chapters there's absolutely no doubt in my mind that you have illustration in your blood and that you are going to make a success out of this. However, before you dash off to start Cold Calling your first client, indulge me for just one more chapter so that I can prepare you for some of the unseen hazards of freelancing in illustration.

Getting Paid By Clients

The first transition that you're going to have to make from salaried wage-slave to carefree illustrator is learning to cope with the new way in which you'll be paid. Remember all those bills you left lying around until the red reminder came in? Well, from now on that's how some of your clients are going to be paying you. Ninety-five per cent of all illustration assignments will be paid for on receipt of your invoice and your accountant will badger you to convert that remaining five per cent to the same method. It will seem very strange and a bit scary at first, but never fear, it's much better this way

Example of an illustrator's book-keeping system

date	details	payments	postage, stationary, advertising	travel
01.05.06	Vogue	500.00		
03.05.06	Royal Mail		4.67	
05.05.06	Partners		8.99	
05.05.06	London Transport			10.00
05.05.06	British Rail			60.00
07.05.06	Harper Collins	1000.00		

and a little planning will soon have your finances back to a predictable level.

The biggest plus-points of invoicing over standard p.a.y.e. salaries are the tax benefits. When you work for an employer you are offered a wage which the employer then deducts tax, National Insurance, company pension contributions and God knows what else on your behalf *before* you even see your money. Any expenses you may have incurred to get to that job such as travel costs, clothes, tools or stationery are not taken into account and have to be met out the money that is left to you. When you submit an invoice to a client, on the other hand, you receive the full sum of money without any deductions and it's up to you to pay the taxman. This is great because it means that you can then deduct your expenditure first and then pay your tax on the **profit** that's left over. Plus, as you will usually settle your account with the Inland Revenue at the end of the year, you can save your tax money in a deposit account and earn a little interest as well.

Being paid on invoice and it's close cousin, bookkeeping, does require a little management but, like anything else, can run quite smoothly if you setup a self-sustaining system to keep your cash in order. The first thing you need to get into the habit of doing is collecting receipts. When you buy a stamp or a box of envelopes, ask for a receipt. When you place an advert or buy materials don't part with a penny until you've had an invoice. Practically everything you purchase for your illustration work (including books and reference material) will be tax deductible, so prove to the taxman that you didn't spend the money on Mars Bars and always backup your spending with proofs of purchase. Then it's just a simple matter of a little basic bookkeeping and your accountant will do the rest. If you adopt an easy to understand column system you'll be in control of the figures and your 'books' should look a little like the example opposite.

145

INVOICE

from Ann Illustrator, 15 Ferguson Street, Manchester
M13 2ER
0161 222 3333

To: Joe Soap
The Soap Works
Pomona Dock
Manchester M4 2ER

date and tax point: 14.03.2006
invoice number: Soap/06/24

For illustration for the Pomona Soap Label, and use
thereof by Soap Works for one year, as
agreed...£1000.00

Total Due Please................£1000.00

<u>Payment Terms</u>: 30 days from issue of invoice please

Many thanks for your valued assignment
& looking forward to being of service in the future

If you stick with a simple column system like the one shown you'll never go wrong. This way you can always see at a glance what you have coming in along with not only what's going out but where it's going. For example, if you're earning five hundred pounds a week and you're spending over a hundred pounds a week at the local post office counter then maybe it's time you rang up Royal Mail to ask about contract rates and the cost of collection from your premises. Figures are not just numbers. They are heartfelt messages to you from your money and they can often tell you how to hold on to just that little bit more of it. Read your figures like a poem, they contain wisdom. Learn to love the process and you'll soon discover that bookkeeping isn't a chore, and, if you make a point of doing your books once a week, or even once a month, instead of leaving it to the end of the tax year (like I usually do!) you will not only have wonderfully self-regulating records but you will also be on top of your spending and have your finger constantly on your own financial pulse.

Invoicing

And, lastly, we come to the final stage in your money harvesting process - invoicing. As we've discussed, as a freelance illustrator you will not be paid a wage by your client, instead you will send them a bill for the fee you agreed on, otherwise known as an invoice. Lots of people find invoices a bit scary at first but they really are very simple to issue and collect. An invoice is simply a request for payment and all your invoice needs to say is who you are and what you want paid for.

A typical illustrator's invoice would look something like the example shown opposite.

148

"The first rule of business is - do other men for they would do you."

Charles Dickens

That's really all there is to it. There only a couple of habits you need to get in the way of when you're compiling your invoices. Firstly, always send in your invoice as soon as you complete the job, don't leave it till the end of the month as many books on accounting would recommend. In fact, show you're keen and try to hand your invoice in when you deliver the job where possible. Secondly, always get your invoice into the hands of the person who commissioned the work from you. Lots of eager young illustrators think that they can beat the payment system by sending their invoice directly to the accounts department of the firm that contracted them. This is not a good idea and shouldn't be done unless the client specifically asks you to, since ninety-nine per cent of all accounts departments will *not* settle an invoice unless it is signed by the person who made the 'purchase' as authorisation. I have heard countless horror stories of invoices which were sent to accounts departments being sent in search of a signature and being lost in internal post systems for five or six weeks, or, even worse, being binned by arrogant accounts executives who simply ignore any bits of paper that don't have the requisite signatures on them. Be warned.

This doesn't mean, however, that you should have nothing to do with accounts departments. Far from it. Like secretaries, accounts executives are very good people to have as on your side and front-liners like ourselves would do well to cultivate a couple of them. So, if you've just completed a job to your client's satisfaction and submitted your invoice it doesn't do any harm to call up the accounts department, introduce yourself, and find out a little about their payment cycles. And what are payment cycles, you may well ask? Simply put, these are the structures which govern the issue of company cheques, and, if you are at all mystic, you'll soon become very enamoured with payment cycles, because, like their lunar counterparts, they control everything and cannot be tampered with. Most firms work on a monthly payment cycle, or, to put it another way, there is only one

"I always travel first-class on the train. It's the only way to avoid one's creditors."

Seymour Hicks

designated day each month when cheques are written, so your invoice had better be at accounts on that day or it'll be another thirty days before you can expect payment.

Therefore, the informed illustrator should always possess the following two facts. One, the length of the payment cycle of your client's firm (some local authorities, for example, work to a three month payment cycle and no amount of pleading can alter it) plus their, hopefully monthly, payment date; and, two, the name of the person who deals with your invoices in the subterranean vaults of the accounts department. Thus armed the freelance can go to her year planner and realistically calculate when payments can be expected. Never make guesses with payment dates. Many freelances have come to grief with policies like "I billed him three weeks ago, I'll have my cheque soon". Soon is not good enough if the phone company's threatening to disconnect you for non payment! So find out that all important payment date and know for sure; most accounts departments run quite efficiently and, as long as you know who's dealing with your invoice, you can always get on the phone and sort things out if a cheque does go missing.

Slow Payers and How to Speed Them Up

As a working illustrator you'll soon come to loathe slow payers. However, like anything else you can learn how to manage them up to a point and the first thing you need to establish is whether the delay in getting cash to you is being caused by a client who *can't* pay or one who simply *won't* pay. Let's take a look at both groups.

Can't Pays usually tend to be ad or design agencies and other middle men. They have contracted you on behalf of another company and are waiting for their client to settle with them before they can pass on your share. Other

152

"If there is anyone to whom I owe money, I am prepared to forget it if they are"

Errol Flynn

Can't Pays are very small fledgling companies with extremely limited cash flows. I used to work for a small independent magazine, for example, who had a nonexistent budget and would wait until they had collected all their advertising revenue before paying their freelances. This can often be a pain in the rear end, especially if you're being offered a low fee to boot, but, again, if you familiarise yourself with the firm's payment cycle you can mark your expected payment date on your year planner or diary and save yourself the bother of sending out reminders. Remember, it is up to you to accept or not accept this kind of payment and if you find you just can't wait three months to be paid it might be best to avoid this type of client. However, I might add that as long as *all* your clients are not making you wait this long for remuneration then it does no harm to have a couple of fledgling slow payers on your list of clients, as long as you've done your homework and know the score!

Clients who *won't* pay, on the other hand, are quite another kettle of fish. These are people who have the resources to pay you, they just don't see why they should when their money's sitting quite happily in their own bank account. Clients like these need to be trained and, if they can't be trained, avoided. The first clue you will have that a client is being reluctant to part with his cash is when you have had a long wait for your cheque, and, secondly, when you try to contact the accounts department they become evasive and are unwilling to give you details of their payment cycle.

Counter clients like these, initially, by snowing them down with paper. Send in your invoice as normal and follow it up as soon as possible with a weekly Statement of Account. This should look a bit like the statement your bank sends you, with records of all transactions, invoices, payments etc, which is ostensibly what it is. However, in business practice, statements are really just polite notes saying "Where's my money?".

Statement
from Ann Illustrator for October 2006

To: Joe Soap
The Soap Works
Pomona Dock
Manchester M4 2ER

12.09.06 Invoice 100/30..............£500
Total Debits£500

Total Credits
...nil

31.10.06
Outstanding Balance £ 500

Terms: 30 days from invoice. Your cheque by return would oblige.

Ann Illustrator

15 Ferguson Street, Manchester M13 2ER

0161 222 3333

A typical illustrator's statement would look like the example opposite.

If you think that the firm are messing you about, send them one of these every week for the first four weeks. (That is, the thirty days of the stated credit terms) If they haven't paid up by then simply ring up accounts every two days until they do, and in your pleasantest voice, say "Hi, it's Ann Illustrator here, I'm just chasing invoice 100/30 which is overdue. When can I expect my cheque?" The key factor to remember here is not to turn this into a fight. All that will do is stress you and send your blood pressure soaring. The purpose of this exercise is to checkmate your client's accounting system which has been set up to improve his cash flow by keeping *you* waiting. However, the client's accounts staff are mere underlings *who don't care about his cash flow*. They just want a quiet life, and, if you deprive them of that quiet life by constantly writing to them and, even better, ringing them up, your cheque will quickly find its way to the front of the queue.

Some people use little stickers on their statements with twee things like "My teddy can't afford his sweeties because your cheque is late" or whatever, which are supposed to fill hard-nosed accounts staff with guilt and have them rushing to the cheque book. Believe me, they won't, mainly because the average accounts executive has seen so many of these stickers that they have become part of the wall paper and she won't even notice them, let alone act on them. I'm sure these "business aids" make the sticker printers very rich but I've yet to meet anyone else who profited by using them. Paper is easy to ignore, polite but firm phone-calls get results.

Lastly, on very rare occasions, it's sometimes necessary to call in the heavies if a client flatly refuses to settle and gives no indication of

"I've been rich and I've been poor - rich is better"

Sophie Tucker

dissatisfaction with the work you did for him. Forget solicitors, they cost a fortune and you can easily do the job yourself using this quick three stage plan. **Stage one**: send a polite but firm letter by Recorded Delivery stating how much is owed and giving a deadline for payment. **Stage two**: if there is either no reply or the client tries to fob you off, contact your local county court (in the phone book under Courts) and ask them for the form and explanatory booklet for taking out a Default Summons. Now don't panic, this honestly is a very simple procedure, all you have to do is fill out who you are, who owes you money and how much you are owed. Now here's **stage three**: *before* you send your summons back to the court and pay their fee (normally ten per cent of the amount you are claiming) photocopy the completed form and send it to your reluctant payer with a letter stating that you regret that if you don't receive a cheque within seven days you will lodge the enclosed without further correspondence. This should get you your money. If it doesn't my rule is if it's under a hundred just chalk it up to experience, write it off and don't work for the client again. However, if it's over a hundred pounds (and you're pretty sure the client has the money to pay you) pay the court fee and take out an action against the bastards!

Financial Planning

Freelancing is all about personal responsibility, and the final thing you need to do before you set out is to take responsibility for your own financial security. Now when I'm doing a seminar this is the stage that everyone starts to get uncomfortable and wants to go for a coffee break. Illustrators tend to be free spirits and don't want to know about writing up figures and making VAT returns and I have to admit that I can't stand the things either! However, as we are now in the business of providing for ourselves and our dependents (if we have any) it's time that we paid just a little bit of attention to our money and its management because, believe me, we are on our own

"Any man who has $10,000 left when he dies is a failure."

Errol Flynn

and no-one else is going to do it for us.

The first step is to assemble our personal money team. Member number one is you, member number two is your accountant. Now, I'm not a great believer in advisors and middle men, (after all, why pay someone to make mistakes for you, you can make them yourself for free) but the one professional that you shouldn't exclude from your payroll is an accountant. Now, I know you may have heard horror stories about accountants who have been billing clients huge sums of money and getting their tax returns wrong for ten years at a stretch - don't worry, you can eliminate this problem by using these two simple criteria to select an accountant - your book-cooker must offer you a Fixed Fee Deal and have Relevant Experience. There are hundreds of accountants in your yellow pages so the first thing you want to do is eliminate anyone who isn't offering a fixed rate agreement, that is, a deal where you are charged a fixed annual fee for the accountant to present your accounts to the Inland Revenue on your behalf. I currently pay my accountant a hundred pounds a year to do this for me and consider it money well spent. Whereas I find the tax return form a maze with no exits, she breezes through it and deals with any queries from the taxman on my behalf without stress to me, and thereby keeps us a happy Jack Sprat and his wife!

Secondly, try and find an accountant who understands our industry. (My own accountant is the ex-financial director of a graphic design firm, for example.) Stick to one-man-bands rather than huge firms where possible, and instead of looking in the phone book, for example, you might find a more user-friendly accountant in a trade directory or advertising in the newsletter of the AOI or other professional illustration association. Better still, another freelance might be able to recommend you to a suitably experienced professional.

160

"When I asked my accountant if anything could get me out of the mess I am in now, he thought for a long time. 'Yes,' he said, 'death would help'."

Robert Morley

Step Two of your Financial Future Plan is a bit harder for people like us. We need to set up a budget. This is the point where the seminar room empties and droves of erstwhile illustrators head for the coffee shops and smoking areas and I have to go out and round them all up like a sheep dog. Please don't panic - you only have to do this once and your budget will not only be simple to set up, but, like having a good accountant, it will give you many years of stress free freelancing.

How to Set Up Your Happy Life Budget

So, what should we do to make life smoother? Well, for what it's worth, here's my three stage plan. The **First Stage** is the paying of your domestic bills and immediate expenses. Write down what you have to pay out each month. Electricity, Gas, Phone, Insurance, Rent or Mortgage, Water, Council Tax, Transport, Materials, Clothes and, of course, Food. Add this up and you have the total amount of your income that's irrevocably spoken for each month so make arrangements for this money to be diverted to the appropriate channels. So far so good.

The **Second Stage** is the setting up of what I call a Three Month Account. You've just worked out the minimum that you need to keep your head above water for a month, now multiply that by three and you'll have the target figure for your Three Month Account. The purpose of a Three Month Account is a bit like having a car fund. It's your safety net in case there's a month, or even a couple of months, when no work comes in. It's a bit like laying in food and firewood for the winter it means you don't go under.

A Three Month Account works like this. Find yourself a nice high-interest-paying deposit account and put the cash machine card in a safe place in your

"Money is better than poverty, if only for financial reasons."

Woody Allen

home - not in your purse or wallet. [Check out your local supermarket, by the way, many of the larger stores are now offering banking services with much higher interest for savers than the traditional finance houses.] If possible, aim to save twenty per cent of your monthly income, but even if you can only afford five pounds a month after the bills are paid, start that account today. Treat your saving like a bill that has to be paid, in fact, I'd recommend that you have a standing order set up to make your payment each month so that you're not tempted to skip months here and there. After a couple of months you won't even notice that you're making payments and you'll certainly be glad that the account is there when the bad times come.

Lastly, we have the **Third Stage**, which is your long-term budgeting. Life, as experience has already proved to you, is unpredictable, but there are a couple of certainties or, if you prefer a metaphor, rocks amongst the shifting sands. The first immovable rock is Christmas. As Joe Karbo has said "Christmas is not an emergency, it happens every year" and as such needs to be budgeted for. So open a Christmas account in a bank/building society of your choice. Your piggy bank is as good a method as any if you stick with it! Holidays, new cars, or whatever you like spending your money on can all be catered for in the same way. And, finally, old age, like Christmas, is also inevitable. If you're over thirty I would seriously consider a pension plan and/or some other form of long term investment for the days when you don't want to be bothered with drawing for your living any more.

In my own case I have a standard pension plan since it gives me back some of my tax and puts it towards my future, plus I buy shares in entertainment and arts-based ventures when I get a bit of unexpected spare cash. However, the choice is up to you. You don't need a conventional pension plan if you don't want one. You can set up an endowment or a share plan. You can play the stock market or become a business angel like the garage

164

"I'm living so far beyond my income that we may almost be said to be living apart."

e e cummings

owner who believed in a young Anita Roddick and currently enjoys a *very* happy retirement. You can back films or West End shows. It really doesn't matter what you do as long as you don't loose sight of the two key facts of the matter. Firstly, you *will* get old and want to retire, and, secondly, the State Pension is nothing short of an insult that will barely keep you in catfood. So plan ahead. There are plenty of excellent books and magazines to inform you of all the long-term options available or, if you're totally bamboozled, you can consult an Independent Financial Advisor for a small fee.

Now, if you're just starting out in your illustration career with twelve pounds fifty in the bank and no idea what you're going to earn, this is all going to sound a bit off-putting so let me assure you right away that no-one, especially me, expects you to set up a financial structure like this from day one. Take it one step at a time. Earn some money, budget for your essentials, then start saving for the short term (your Three Month Plan). Once you've been in business for about a year you can review things and start thinking about the future and long-term savings, in fact, the key to financial security lies in regular reviews. Write your review date on the calendar and mark it in your diary. Don't consign it to Someday Isle (ie, someday I'll sort out a pension etc). Decide when you're going to review things, mark a firm date to do it on, and stick to it. It won't hurt and it'll make life a lot easier in the future if you start planning now.

166

"As repressed sadists are supposed to become policemen or butchers, so those with an irrational fear of life become publishers."

Cyril Connolly

Appendix

Portfolio Drop-Offs & How You Can Avoid Them

A rather pernicious sickness currently running wild in the design industry is the present vogue for "Portfolio Drop-Offs". The theory behind this practice is - assumably to make the best use of the Art Director's time - one day per week is set aside for the viewing of portfolios where illustrators are asked to leave these and return for them later after the Art Director has meticulously pored over them in their absence.

Needless to say this is not a great way of working. As sales professionals we should really be present at *all* portfolio presentations, and surely even the busiest art director in the world could allocate one day each week or even fortnight to meet new illustrators in person.

It becomes, however, an even more atrocious practice when it paves the way for all sorts of related abuses. The most common occurrence is a lazy Art Director using the drop-off as an easy brush-off tool, and deposited portfolios either remain at reception desks all day or go up to the art department for a junior dogsbody to stick post-it "Thank you for handing in your portfolio" notes to them and send them back, unopened, for collection.

Even if the art director actually does bother to look at your work, I still think this an unprofessional way of working for both parties. Firstly, it presupposes that as an illustrator you have nothing better to do with your day than trot down to a client's office, kill four to six hours, and then trot back in the hope that the client *might* have bothered himself to look at your

"A publisher would prefer to see a burglar in his office to a poet"

Don Marquis

work. Secondly, it is not a way of working that would be acceptable to clients if the roles were reversed. Imagine, for example, if the Penguin Books rep rolled up at Waterstone's and the buyer said, "Oh just leave your sample case and pick it up at four o'clock"! My case rests.

So, how do we avoid getting into portfolio drop-off situations? Firstly, if you phone a client and are asked to drop your portfolio at the door have an excuse ready that makes this impossible - mine is "I'm only in London for the day", which is true as I live in the back of beyond. If this doesn't work you can always try showing up anyway and bluffing your way in, which sometimes works and sometimes doesn't - I've got into lots of offices very successfully in my time but have been chucked out of twice as many!

If, however, the Art Director refuses to budge and the firm has a very strict door policy so that there's no way you can get past security you will have to decide it you still want to pitch to them or let them live without your talent. If you decide to go ahead my advice is to create a second drop-off portfolio which should include a brief written commentary on your work, eg pages should be subtitled with "series of four posters for McVitie's Biscuits, Gold Medal winner at Images 2006" sort of stuff, and there should be a **clearly marked** envelope enclosed at the end with your business card and any samples you want them to have. Follow the drop-off up with a phone call and/or letter to the art director and try and obtain a personal interview now that your work has been vetted. It's not a perfect way of working but it makes the best of a bad situation and it will at least help you to know if they bothered to open your book or not!

Handy Contacts

The Association of Illustrators, 2nd Floor, Back Building,
150 Curtain Road, London EC2A 3ER.
020 7613 4328
www.theaoi.com

The Graphic Aritists' Guild
90 John Street, Suite 403,
New York NY10038-3202
212 791 340
www.gag.org

CONTACT
Unit 39 Bookham Industrial Estate
Church Road, Bookham
Surrey KT23 3EU
01372 459559

The Creative Handbook
East Grinstead House
East Grinstead RH19 1XA
01342 326972

American Showcase
915 Broadway
New York NY10010
USA

Further Reading

Black, A & C — **The Writers' & Artists' Yearbook**

Cox, Mary — **Artists' & Graphic Designers' Handbook**

Karbo, Joe — **The Lazy Man's Way to Riches**

Williams, Art — **All You Can Do Is All You Can Do**

Boldt, Lawrence — **Zen and the Art of Making A Living**

Von Oech, Roger — **The Creative Whack Pack**

Smith, Ron — **Writing for Profit And PR**

Sinetar, Martha — **Do What You Love, the Money Will Follow**

Godden, Seth — **Purple Cow**

Godden, Seth — **The Big Red Fez**

Godden, Seth — **Unleashing the Ideas Virus**

Gladwell, Malcolm — **The Tipping Point**

Gladwell, Malcolm — **Blink**

Pogue, David — **Max OSX - The Missing Manual**

Kent, Peter — **Search Engine Optimization for Dummies**

"There is only one difference between a madman and me. The madman thinks he is sane. I know I am mad."

Salvador Dali

ABOUT the AUTHOR

British multi-media artist, Max Scratchmann, was born the son of a Dundee Jute Wallah in Calcutta, India, in 1956, and sold his first painting in 1973 at the age of seventeen. He published numerous cartoon illustrations in the late 1970s and entered the 'commercial art' world in the early 1980s producing a Super 8mm Fanzine and then graduating to writing and illustrating for **Classic Images** and **Movie Maker** magazines.

However, he soon became restless and, after writing the unofficial biography of Betty Boop in 1984, discovered collage and branched out into full time illustrating for media giants like IPC and Longman, as well as for numerous medium sized and independent publishers. He has produced comics and children's books and was exceptionally prolific during the 1990s when his work appeared in the UK, USA and Japan. He has illustrated countless theatre posters and CD sleeves, over forty book covers and several hundred magazine spots and was the recipient of awards from **Dimensional Illustrators** in New York for three years running.

In the early twenty-first century Scratchmann stuck a cautious head above the parapet of the familiar illustration scene and started exploring the world of art galleries, producing three-dimensional "box" artwork as well as digital images. Then, in 2005 he began working with film and his exhibitions now include video installations and animation.

Max Scratchmann is the author of the internationally popular "**Illustration 101**" and a monograph of his recent digital work, "**Theatres of Dreams**", has been published by Poison Pixie as a limited hand-signed edition.

As well as his artistic work for illustration and exhibition he is the author of the hilarious soon-to-be-published **DOWNSHAFTED**, a grumpy account of the seven years Scratchmann spent in the remote Orkney Islands, plus he is currently hard at work writing a blackly humorous memoir of his childhood in India and *very* unhappy teenage years in Dundee, plus a copiously illustrated collection of eccentric comic verse.

Also by Max Scratchmann

THEATRES of DREAMS

It begins with a spark, a shadow, a fleeting chimera of a showman's slight of hand and ends in a dark theatre after a century of broken dreams.

Commencing with "*Les Frères de Lumiere Découvrent le Cinéma*" and concluding with the bitter-sweet "*Unrequited Love*", where a lonely fan sits clutching her popcorn in a deserted picture palace, **Theatres of Dreams** is Max Scratchmann's personal journey through over a century of cinema.

There is Fine Art, Pop Art, German Expressionism, French Surrealism, Painters, Photographers, Cinematographers, Matinee Idols and, above all, all Scratchmann's personal dream worlds from almost five decades spent sitting on plush velvet seats in the popcorn-scented darkness.

A hand-signed limited edition of 100 copies

£24.95

ISBN 978-0-9537307-2-8

Poison Pixie Publishing

We hope that you have enjoyed this
Poison Pixie art book.

If you would like to be kept informed
about new art & design and / or fiction titles
please visit our website and subscribe to our
mailing list or email us at:

marketing@poisonpixie.com

to receive our FREE newletter.

(**The Pixie Promise:** We will *never* pass your details on to any third party or pester you with spam)

POISON PIXIE (Publishing) LTD

Publishers of Cutting-Edge Art and Fiction Since 2004

www.poisonpixie.com

Printed in the United States
106414LV00005B/45/A